PHOTOGRAPHING MODELS AND MINIATURES

Paul Brent Adams

AMBERLEY

To Rick and Kaye, for always being there.

First published 2017

Amberley Publishing
The Hill, Stroud
Gloucestershire, GL5 4EP

www.amberley-books.com

Copyright © Paul Brent Adams, 2017

The right of Paul Brent Adams to be identified
as the Author of this work has been asserted in
accordance with the Copyrights, Designs and
Patents Act 1988.

ISBN 978 1 4456 6254 1 (print)
ISBN 978 1 4456 6255 8 (ebook)

British Library Cataloguing in Publication Data.
A catalogue record for this book is available from
the British Library.

Origination by Amberley Publishing.
Printed in the UK.

Contents

Introduction

The modern digital camera has made close-up photography both simple and fun. If the camera is left on Automatic, it will handle the complex, technical side of photography, leaving you free to concentrate on your subjects – anything from lions to locomotives and jet fighters. Models can be photographed against a plain background for cataloguing your collection, keeping records for insurance purposes, or selling online; or put into complete miniature worlds created with simple household items, toys, and model railway accessories. You can step back in time to the age of the dinosaurs, battle mythical dragons, or create scenes of everyday life.

There have been many previous books on close-up photography – most of them written by either professional photographers or hard-core photography buffs. This means they are very technical, use many obscure terms, and require lots of expensive equipment. This one is different. Being a modeller and collector, rather than a photographer, I like to keep things simple. Everything is therefore as basic as possible; you will not need a mountain of expensive photographic equipment, nor a fully-equipped home studio. A lot of modern photography books also contain lengthy chapters on how to manipulate your photographs using the many computer image-editing programmes that are available. Not this one. To me, doctoring a photograph is simply cheating. A model photo should be a photograph of a model; it

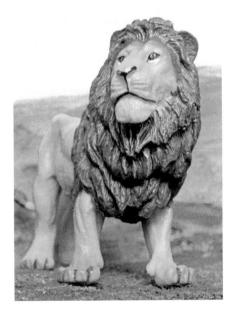

A toy lion surveys his miniature domain: a simple grass base and a sheet of blue card that has been painted with green hills, streaked on with a piece of sponge.

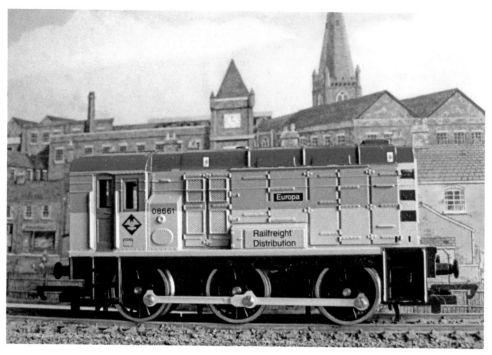

The Hornby Class 08 diesel engine in 00 (1:76 scale). It stands on a short section of ballasted track, with a printed model railway backscene behind it; all available in any shop selling model railway supplies.

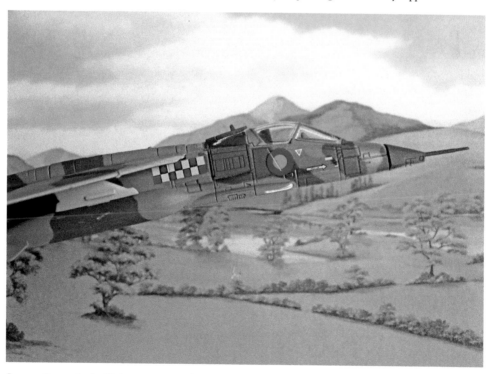

Sepecat Jaguar jet in flight, against another model railway backscene, by the British company Peco. The backscene is the only item required for this shot, other than the model itself.

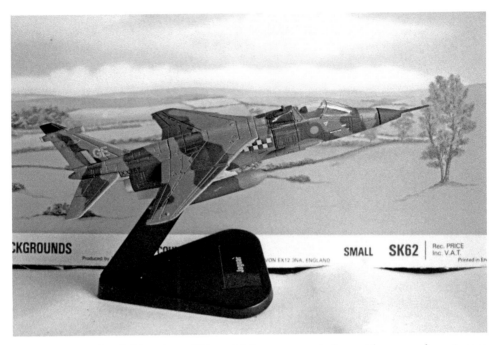

Jaguar strike aircraft in RAF markings. This model, from a partwork, does not have an undercarriage, so it can only be displayed on its stand. The need to keep this out of shot limits the way such models can be photographed, but cockpit views are still possible.

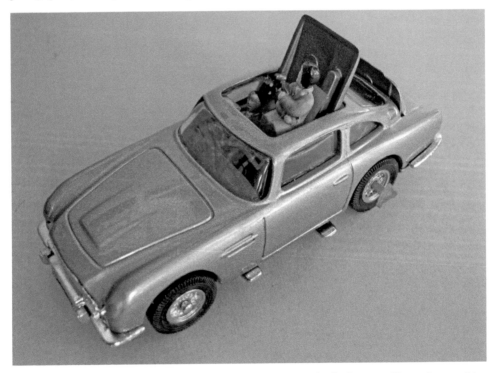

The second version of the Corgi James Bond Aston Martin DB5, clearly showing off its various working features – standing on a single sheet of plain blue card.

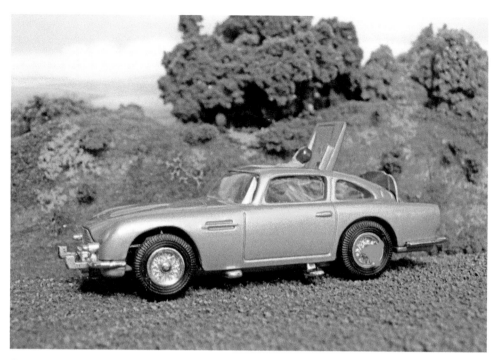

A roadway on an old placemat; a small hill of polystyrene foam, some trees, and a barely visible Peco backscene combine to create a complete miniature world for this Corgi Aston Martin.

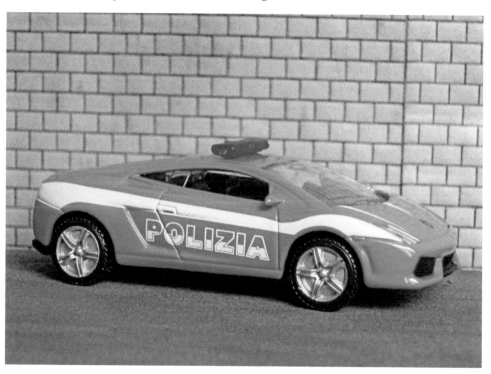

Siku Italian Lamborghini Police Car – a real vehicle. The road surface is a board painted with grey texture paint by Tamiya. The wall is another board covered in sheets of model railway paving stones.

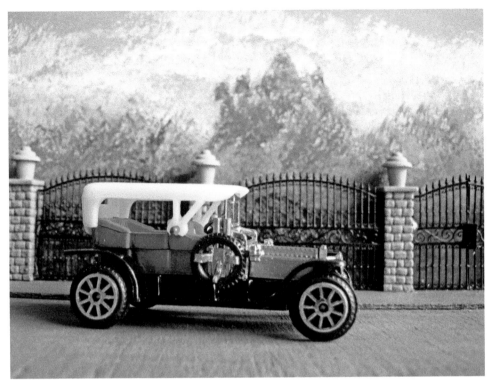

Small-scale vintage Tourer. The fencing is a model railway accessory, but is very delicate, which is why it has been fixed to the backscene.

This plastic wrought-iron fencing is very delicate and must be handled carefully. The range of fencing and walls available to railway modellers is vast. The painted backscene was made by dabbing on foliage colours with a sponge.

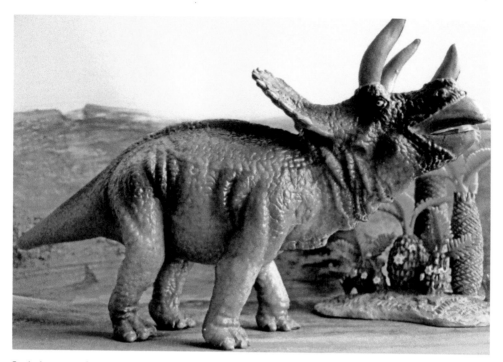

Light brown card streaked with green and brown acrylic paint, blue card streaked with green hills, a toy plastic tree, and we are back in the Cretaceous period, 65 million years ago.

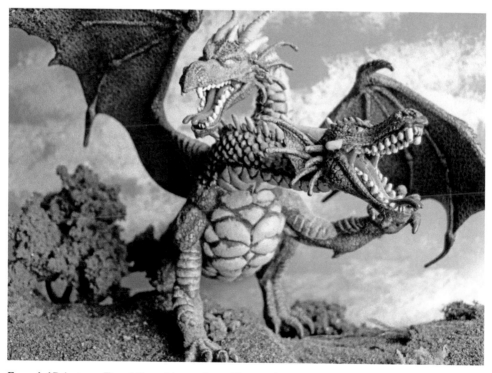

Expanded Polystyrene Foam hill, model trees, clump foliage, and sponge-painted sky. It is not necessary to have the entire model in shot – with his wings extending well beyond the edges of the photo, this dragon seems enormous.

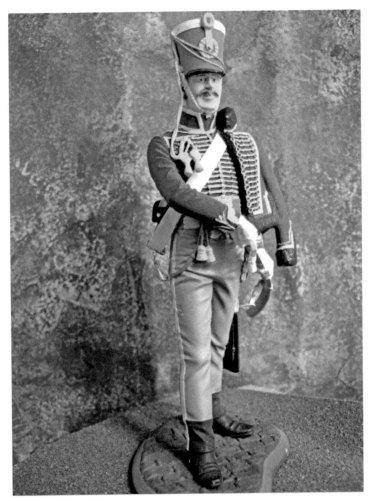

Very large-scale Napoleonic cavalryman, from the British 10th Hussars – a resin and metal kit. His colourful uniform stands out well against the soft, sponge-painted background, and grass mat.

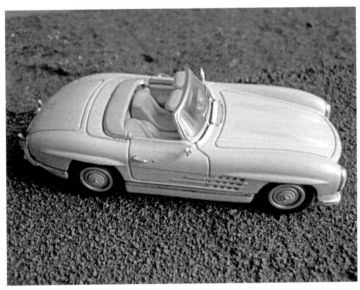

Corgi Mercedes 300SL convertible on a simple roadway. Digital cameras can be set to take black-and-white photos if required, giving such shots more of a 'period' look.

A small Hot Wheels '35 Classic Caddy (Cadillac) looking at home in a 'period' sepia photograph. Black paper roadway, hill, and painted sky.

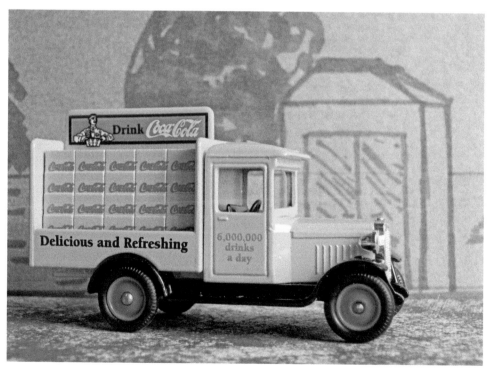

Lledo Coca-Cola delivery truck. The brown roadway is painted card, while the backscene was drawn on heavy paper with a brown felt-tip pen.

Some models have an opening bonnet, or rear engine cover, revealing a detailed engine. If you are selling online, this is the sort of detail buyers will want to see.

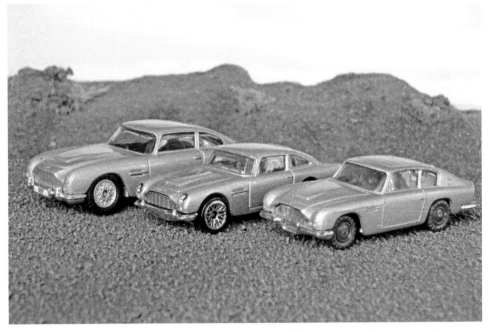

Small-scale Corgi, Hot Wheels, and Husky Aston Martins. An old placemat covered in grey-painted tea leaves, a small hill covered in model railway grass, and a Peco sky background provide a clean and simple setting.

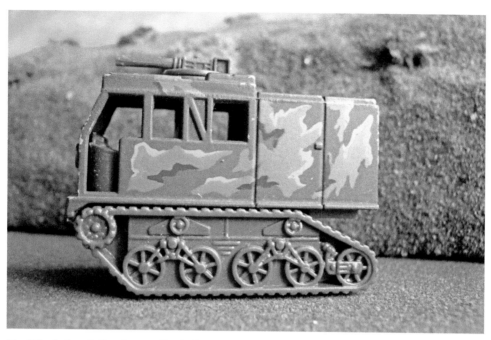

Hot Wheels Assault Crawler, actually a high-speed tractor, used for towing artillery across country. Grass mat, expanded polystyrene foam hill, and painted sky.

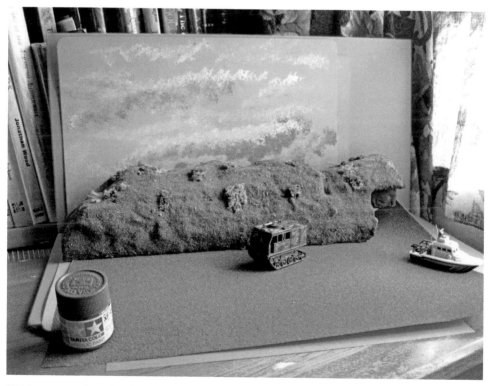

This is my entire home 'studio' – a small table by a window. There is enough light coming in the window for photos like this. The small grass mat wants to roll up, meaning it needs a weight at each corner to keep it flat.

should not be faked on a computer. All of my photographs are genuine – none of them have been tampered with in any way, no special effects have been added, nor have any images been combined. Even the black-and-white and sepia photographs were taken by changing the camera settings, and not by computer trickery; nor is any trickery involved in those shots showing a colour subject against a monotone background.

I bought my first digital camera just a few years ago, principally to take close-up photos of models; my old film camera having recently died. I soon discovered how easy it was to use – far simpler than its predecessor. With the camera taking care of the basics, I could devote more time to arranging each shot. Being a modeller I really enjoy creating miniature sets, but I realise not everyone is a keen modeller so this side of things has also been kept as simple as possible. All the model settings shown here are very easy to make, often using scrap materials, which also means they are very cheap. If you prefer, you can buy ready-made scenery in model or toy shops, in which case there is no modelling involved at all. My collection of scenery and props has been built up over several years; there is no need to acquire everything at once.

My home 'studio' consists of a small table by a window. Every photograph in this book was taken using this set-up, and all but one use natural light. Everything has to be packed away after use, in a cupboard or drawer – another reason for keeping things simple and compact.

Cameras and Equipment

Cameras

Digital cameras began to appear in the 1980s. Early models were expensive, and picture quality was poor, but things improved until they equalled normal film cameras. The modern digital camera is highly automated and simple to use. You no longer need a complex and expensive camera to take good close-up shots. Even an inexpensive compact will provide excellent results. Nor is any extra equipment required – as it was in the old days – apart from a small tripod. If you already have a camera, then you can probably start taking photos straight away. If you do not, or your camera is unsuitable, you may need to buy a new one, making sure that it has the features required for close-up work.

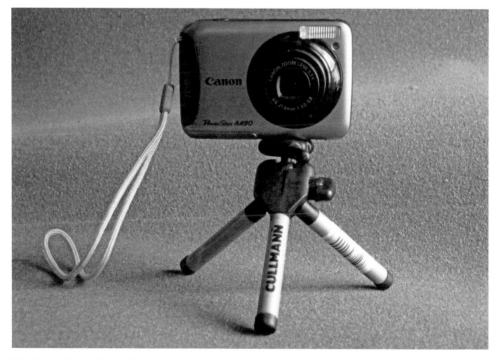

The Canon PowerShot A490 camera is so clever it can even take a self-portrait, with the aid of a mirror. The result will be a mirror image, but this can be flipped in an image-editing programme so everything is the right way round. The camera screws to the tripod, which is adjustable. The background is a large sheet of Woodland Scenics ReadyGrass grass mat.

There are several types of digital camera: very simple 'point and shoot' models that cannot be adjusted; compacts that are more capable than many older cameras costing ten times as much; bridge cameras that fit in between the compact and the DSLR. Top of the line is the digital single-lens reflex camera, which often has interchangeable lenses, or a very powerful zoom lens. While I have not used a DSLR, I did use a SLR film camera for many years. Based on this experience, I would actually recommend a good compact over a DSLR for tabletop work. It is smaller, lighter, and easier to use in a confined space than the bigger DSLR, which in turn means a smaller and lighter tripod. It will also be a lot cheaper.

My own camera is a Canon PowerShot A490; a 10 megapixel compact, introduced in 2010. It was bought in a sale, and even with the memory card and tripod the total cost was the equivalent of less than £70. Shop around, and you may do even better. In the world of photography the A490 is regarded as a basic model, with limited features. In fact, it is a first-class camera, at a modest price, that has done everything I have ever asked of it. It is capable of taking high-quality photographs that are suitable for book or magazine publication – even a book on model photography. All of the following advice is based on the features of the A490, and the terms that Canon use for its features and controls. Your camera may differ in detail, but the basics are going to be the same.

Second World War German Puma armoured car. The roadway is a short length of wood, covered with Tamiya texture paint, which is available in different colours; a painted plastic stone wall, some loose foliage, and a Peco model railway backscene.

The Puma armoured car on a plank, showing how basic the set-up is – even oddments like this have their uses. The wall and the bushes behind it ease the transition between the foreground, and the printed backscene.

The main feature that any camera needs for close-up work is the ability to focus accurately on small objects at close range. If you are buying a new camera specifically for model photography, try it out in the shop and find out just how close you can get. Make sure it will be able to handle the items you want to photograph. There are other very desirable features, which most cameras seem to have these days: a zoom lens – this does not need to very powerful for tabletop use (the 3.3x zoom on the A490 is fine) and only optical zoom is important; digital zoom can be ignored – a self-timer, and a socket in the base so the camera can be screwed to a tripod. The ability to vary the brightness setting, and deliberately over or underexpose a photograph, is also useful. These are all found on the A490. Instead of a viewfinder that you look through to compose your photograph, there is a large liquid crystal display screen on the back of the camera, which allows you to see exactly what the camera sees, and thus what the final photograph will look like. Some cameras have a hinged display screen that can be pivoted to give a better view, no matter which way the camera is facing. Mine has a fixed screen, which has not caused any problems. There may be other features on other cameras that you might find useful, but none of them are going to be vital.

Before embarking on any actual photography, it is a good idea to read the instruction manual. Actually, there may only be a basic printed guide to get you started, with the main manual being included on a CD with the camera, or available online. If there is an electronic version, print it out so you can refer to it easily. Keep the pages in a clearbook, which has clear plastic pockets instead of pages. These are available in any stationery shop, and will prevent the pages getting worn, or misplaced.

Although this is a book about digital photography, nearly everything in it also applies to normal film cameras. Generally, the simpler models would not be able to focus as closely as even a digital compact, so for model work something more complex and expensive would be needed. This usually means a 35 mm single-lens reflex camera. Using mirrors and prisms, looking through the viewfinder you see exactly what the lens sees; something even a basic digital compact can do. This makes composing and focusing much easier than if the lens and viewfinder are separate. SLR cameras can usually be fitted with a wide range of different lenses and accessories for close-up work, adding to their cost and complexity. I used a SLR for close-up work for years, but I much prefer my little Canon A490.

Horrible Technical Stuff

Aperture is the opening through which light enters the camera, the size of which is measured in F Stops. The larger the opening and the lower the F-number, the more light enters and the shorter the exposure time, but the depth of field is reduced. A small aperture and a high F-number increases the depth of field, but also increases the exposure time.

Exposure is the length of time the shutter is held open, allowing light to enter the camera; measured in seconds or fractions of a second. Short exposure times reduce the chances of movement or camera shake affecting the shot.

Modern cameras have a built-in light meter, which will measure the light available; adjusting the lens aperture, exposure time, and ASA/ISO rating to suit. It can also fire the flash, if this is turned on.

ASA or ISO rating; the sensitivity of film or a CCD to light, also called film speed, which can be fast or slow. A high number means the film is more sensitive and can take photos in poorer light or use a higher shutter speed, but the image becomes grainier as it is enlarged. A low number means finer quality, but exposure times are increased. Digital cameras will automatically select the ASA/ISO rating in combination with exposure and aperture, or you can set it yourself.

Depth of field is the portion of a photograph that is in sharp focus. In close-up photography this can be very limited, leaving both the foreground and background blurred. The smaller the lens opening, the greater the depth of field.

Strictly speaking, macro photography means the subject is photographed larger than life size, but it often just means extreme close-up. A zoom lens allows you to move in on your subject without moving the camera itself. There are two types of zoom: optical, in which the length of the lens – the focal length – is adjusted to magnify the subject; and digital, in which part of the image is simply blown-up, but eventually the quality suffers. A bar appears on the display screen showing the level of zoom, and this changes colour as the camera goes from optical to digital zoom. I never go beyond the optical zoom range of the A490.

In a digital camera light enters the lens and strikes a charge-coupled device, rather than film, and this records the light as a series of tiny square dots, called pixels, or picture elements. A megapixel is a million pixels. The higher the megapixel rating of a camera, the higher the quality of the photograph, and the more it can be enlarged without a loss of clarity, although this also depends on the quality of the lens.

Self-Timer

This is one of the most useful features to be found on any camera and will save you from many ruined shots caused by camera movement. It can be difficult to hold a camera steady during long exposures, even if you correctly brace yourself with your arms against your body and hold your breath. Mounting the camera on a tripod, or even resting it on a simple block of wood, will hold it steady. To avoid the risk of moving the camera as the shutter button is pressed, use the self-timer; this is usually a button marked with a clock face. The timer on the A490 has two standard settings – two seconds and ten seconds – or you can choose a custom setting. Two seconds is fine. Once the timer is set, the delay will be applied to each shot until it is turned off. Set up your shot as usual, press the shutter, and after the set delay the camera will take the photograph.

There is one slightly annoying thing to watch for. In order to save battery power, the camera will automatically turn itself off if it has not been used for several minutes – probably while you are busy setting up the next shot. This feature can be turned off, but that might lead to flat batteries if you forget to turn the camera off yourself. When the camera turns itself off, it also turns off the self-timer, so when you turn the camera back on to take the next shot, you also have to reset the self-timer.

Memory Cards

Digital cameras store photographs on removable memory cards, equivalent to film. There are several different types available, so make sure you get the right sort for your

camera. They also have different memory levels, measured in gigabytes. The number of photos that can be stored on the card depends on the picture quality/file size set on the camera – there will generally be several standard settings to choose from – but can run into the thousands. High-quality photos use a lot of memory, so fewer can be stored, but I have never run out of memory using an 8-gigabyte card, even at the highest quality settings. Which setting you opt for will depend on what you want the photos for: to print out and keep, or just for internet use. Because many of my photographs will be published, I always use the highest quality settings. With the 10-megapixel A490, this means most photos have a file size of just over 2 megabytes. Cards need to be formatted, or initialised, when first inserted into the camera, which deletes anything already on the card, so be very careful if reusing a card that might have something on it you want to keep.

A major advantage of digital cameras over film cameras is that it is no longer necessary to constantly change rolls of film – something I really appreciate. You can still remove the card from the camera, and replace it with a new card, just as you would with film, and keep the card somewhere safe. However, I regularly transfer all the photos from the camera to my computer and back them up on to a USB stick or other storage system, in case anything happens to the computer, then delete them from the camera. This avoids any need to handle the tiny cards – and they are *really* tiny.

Batteries

Everything on a modern camera is powered by batteries – on the A490, a pair of AAs. It is best to only use batteries intended for use in cameras and similar items as these will last longer than those of lower quality. Naturally these are the most expensive. The camera manual will have a list of recommended types, some of which are rechargeable. Always keep at least one spare set of batteries on hand – it is very frustrating to start a photography session and find your batteries are flat. Using the flash will also shorten battery life; another good reason for only using natural light. There is also a small battery to power the date/time function, but this lasts a very long time – I am still on the original that came with the camera.

Tripods

Next to your camera, a tripod is your most essential purchase. It keeps the camera steady, allowing you to take better photographs, and have fewer failures due to camera movement. Tripods are not that expensive, and will likely last forever. They are basically an adjustable stand with three legs, and are intended to hold the camera steady, and in the same position, as you take photos. The camera is screwed to the tripod – assuming it has the necessary socket in its base – and can be adjusted up and down, as well as side to side, then locked in place. There are large and heavy tripods for large cameras, and much smaller tabletop models for indoor use. A small model is all we need here, as it will not take up a lot of space. A wide range of sizes and types are available in any specialist camera shop, and sometimes other shops selling cameras.

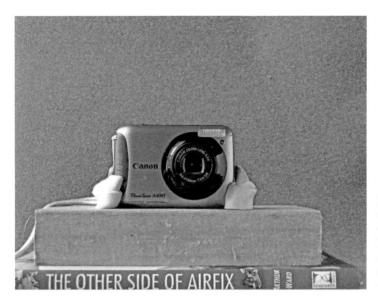

If you do not have a tripod, a block of wood will do. Blu-Tack will hold a small camera steady, but it is not suitable for anything too heavy.

Make sure the tripod is stable, even with the camera tilted well forward. This is especially important with something like a large DSLR camera as some lenses, or attachments, are longer and heavier than the normal lens, which will throw the weight further forward, making the tripod less stable and more likely to tip over. It is a good idea to take your camera with you when shopping for a tripod, or buy the camera and tripod at the same time, so you can try them out together.

My tripod is actually a little too small and light. It is perfectly stable if the camera is upright, but tips over if the camera is angled down too far. This means placing a weight over the rear leg to hold it steady. Buy a good, sturdy tripod to begin with. If you already have a full-size tripod, it can be set up next to your work table, but watch out for the legs.

If you do not have a tripod, or would rather spend your money on models, there are alternatives. The camera can simply be rested on a block of wood, or anything else solid and stable enough to support it. A small camera can be held in place, and its position adjusted, with a couple of large blobs of Blu-Tack, or a similar product. This is similar to plasticine but is not greasy and will hold light objects in place. It is available in any shop selling stationery. However, it is not suitable for large and heavy cameras, such as a DSLR; for these you need a proper tripod.

Lights

Honestly, I cannot be bothered with the complexity (or the cost) of a proper photographic lighting set-up: different types of bulbs, some of which produce considerable heat, which can damage delicate subjects; 'colour temperature'; and finding somewhere to store everything. My sole lighting source is the sun, which is free. All my model photography is done indoors by a window. Direct sunlight will produce patches of light, and heavy shadows, so the models are kept back slightly from the window, in indirect light. This does mean longer exposure times, but the shadows are much softer.

After a few experiments, I decided not to use flash, and keep it turned off. Flash also uses up a lot of battery power, reducing the number of actual photographs you can take. If the light is coming from only one direction, such as a window, the side of the model facing away from the light may be too dark. If there is no other light source to brighten this area, the existing light can be bounced back on to the model, which will reduce the level of darkness. A piece of white card, a piece of foamboard, or even a mirror can be used as a reflector. Position it just outside the area of the photograph, and adjust until the lighting is correct. Only one photograph was taken with artificial light, and this used a normal household ceiling light, shinning from above. No adjustment was made to the camera; however, there is a setting for indoor use. If you want to use lights, adjustable table lamps – the type with flexible goosenecks – would probably be the most suitable.

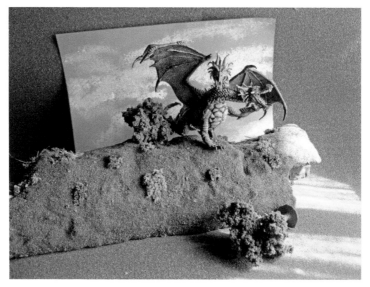

Another reason for close-ups: our sky is simply too small to provide a background for the entire dragon. Direct sunlight coming in the window is creating patches of light and shade. Further away from the window, the light is more diffused and even.

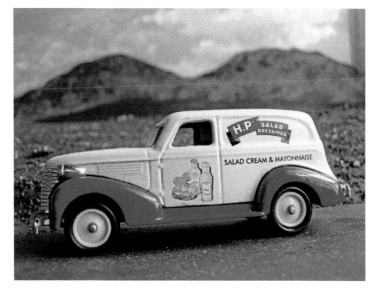

Lledo 1939 Chevrolet Panel Van. The hill just behind the van is modelled, while the more distant hills are only a painted cardboard cut-out.

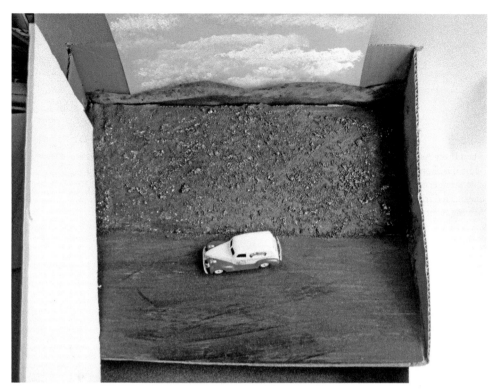

A roadway and hillside built into a cut-down cardboard carton. A slight gap at the rear of the hill allows different backscenes to be slotted in. Held like this, they will not fall over. A piece of white card to one side is used to reflect light into areas of shadow.

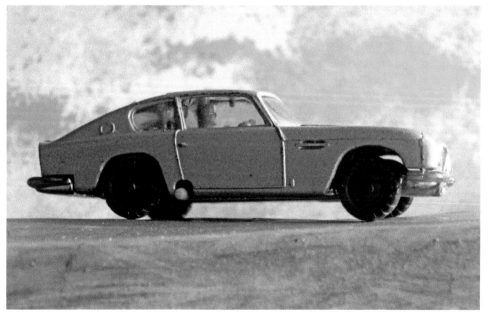

This shot could use a little more light, reflected on to the front of the subject using a piece of white card or foamboard. Simple painted hillside, and sponge-painted clouds.

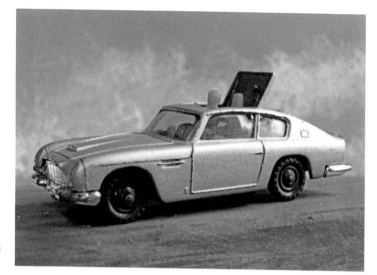

The Husky Aston Martin is about to send its passenger on an unexpected trip. Light is being reflected on to the nose of the car with a card reflector. Roadway and sky are the only items required.

Matchbox Models of Yesteryear 1937 Cord convertible, against a sponge-painted background. This is the only photograph taken using artificial light – normal room lighting is a little too yellow, but the camera can be reset for indoor use.

The Home Studio

It is better to work indoors rather than outside, as there is no wind or rain to contend with. I do not have the luxury of a permanent home studio, so all my equipment must be put away after each photographic session. The main requirement is a solid and stable piece of furniture on which to set everything up – such as a table or desk. Even a small, folding table will do. If more space is needed, use a chair. Backscenes and the like can be propped up against a wall, or another piece of furniture. Everything, including the tripod, rests on the table. Leave yourself enough space to move around freely when setting up each shot, and keep the items you will need during the session close by, but out of the way.

Scenery and Props

There are a few general points about scenery. Texture and fine detail will normally only be visible at fairly close quarters. At a distance detail disappears, and colours become muted. Pure black or white cease to exist, appearing dark grey and off-white. Large areas of one colour simply look wrong, and they should be broken up by mottling with other colours. A gloss finish is seldom realistic, and will often make a small model appear very toy-like. Matt or semi-gloss finishes look better and are easier to photograph, as reflections will be less of a problem.

You do not have to build large sets for your models, although this will depend on their size. Even the mere suggestion that a world exists beyond the confines of the photo is often enough. It is not necessary to show the whole of a hill or a building to convince the viewer that it exists. Usually we only see parts of the world around us anyway, so even if we can only see part of a wall we just assume that the rest of the building is there. Even a very simple set-up can look full, which is why I seldom use smaller props such as street lamps or other items.

Blobs of Blu-Tack are very useful for holding things in place, as long as they are not visible in the finished photograph. Most of the items we need can be found around the home. More specialist items can be found in model shops (which are becoming rarer) and some toy shops. Model shows and collector's fairs frequently have tables selling both new and second-hand models and accessories, giving you a chance to pick up some unusual items. Several of the models shown in the photos were bought at such shows. Non-modellers will be able to find assembled and painted kits for sale, although

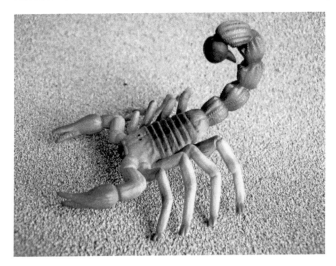

Several companies make highly detailed toy animals in plastic, including this scorpion. Stinger at the ready, it poses on a simple sheet of Woodland Scenics desert sand, which does tend to come off its backing. Coarse sandpaper would be an alternative.

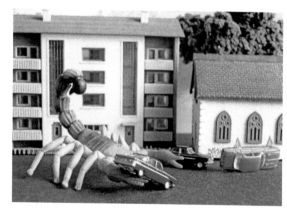

Giant scorpion on the rampage, throwing N gauge model cars around as though they were toys. A typical scene from a 1950s science-fiction movie – similar scenes could be produced using model gorillas or dinosaurs.

Two N gauge model railway buildings (these are unpainted, coloured plastic), and three cars, with loose clump foliage – all that is needed for a busy scene, with no small detail props such as street lights. The use of such small models makes the scorpion appear enormous.

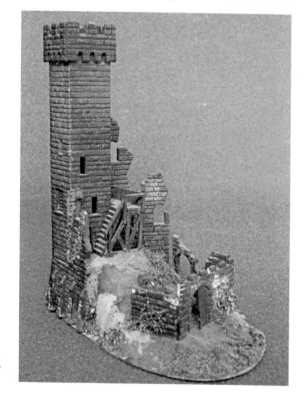

This ruined tower, clearly built from a kit, was picked up at a model collector's fair. It just needs a wash, and a little paint. Overall height is 132 mm, including the base.

standards do vary. Some model shops also carry second hand models. Often such items will need a gentle clean, and possibly some repair. Model buildings will also need their resident dead spiders removed. Sometimes I buy interesting looking items with no clear idea of what they will be used for – just because I like them. Other bits and pieces, mainly old toys, can be picked up at school fairs and in charity shops. Even if an item is incomplete or broken, it may still be useful. There are many companies producing supplies for modellers. Several of these are mentioned here, but they are not the only ones – there are plenty of alternatives available, and many items can be made at home. Often the deciding factor in what you use will be what is available locally, this is certainly true in my case. In the larger scales, such as 1:12 and 1:24, some of the items aimed at dollhouse modellers may also be useful. I have tried to keep the advice on building model sets as simple as possible. For anyone who wants to go into this subject in more detail there are many books on railway modelling, including specialist volumes on scenery, diorama building – usually aimed at military modellers – and making wargames terrain.

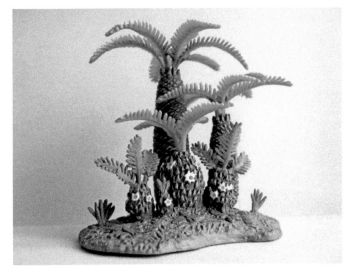

Who could resist this wonderful group of plastic prehistoric trees by CollectA – even though I had no idea what I was going to do with it. Similar trees can still be found in the more arid parts of the world.

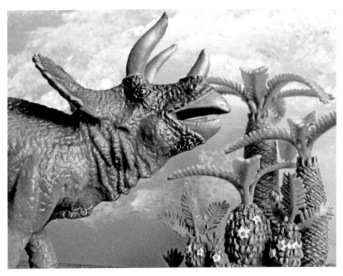

The low camera angle helps give an impression of size and weight to this toy dinosaur, although the slight sheen of bare plastic is a problem.

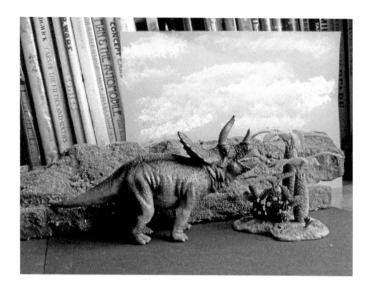

Triceratops about to have lunch. By our standards an elaborate set-up: green card ground, hill, plastic tree, and painted sky.

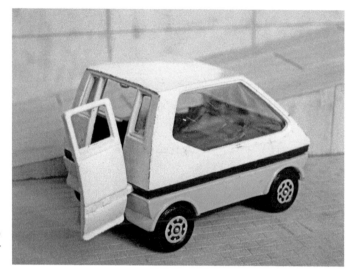

Corgi Minissima showing off its opening rear door. Textured plastic card sheet with a toy skateboarding ramp in the background, which only required painting.

A toy skateboarding ramp, picked up from the toy table at a school fair; painted light grey, and weathered with streaks of darker grey. Old toys such as this often make good (and cheap) props for model photography.

Tools

Very few tools are needed for modelling, and most of these you will already have around the house. Keep everything together in a box, so it is to hand when needed.

Full-size scissors and small nail scissors.

Modelling knife with replaceable blades, for general cutting duties; and a really sharp one reserved for cutting expanded polystyrene foam and foamboard, which will tear if a blunt knife is used.

Metal ruler, marked in both inches and centimetres if possible. Used both for measuring, and as a cutting guide – a task for which wooden and plastic rulers are unsuitable.

A small hacksaw may be useful, but is not essential.

Clippers or side-cutters, for removing plastic parts from the sprue (plastic frame).

Tweezers are useful for holding small items. A small screwdriver for opening tinlets of paint; and adjustable pliers or a jar opener for opening jars of paint. Pliers for tearing sponges into irregular shapes.

Emery boards are good for the small sanding jobs involved in modelling. Fine needle files in various shapes are useful, but only if you plan on doing a fair amount of modelling.

Brayer for rolling backscenes out flat. A rolling pin could be used instead, but these require two hands.

Self-healing cutting mats are very useful, and are available in a range of sizes.

Clamps, bulldog clips, the mini clothes pegs used in craft work, and rubber bands, for holding things together while the glue dries.

Paper towels or rags, for cleaning up.

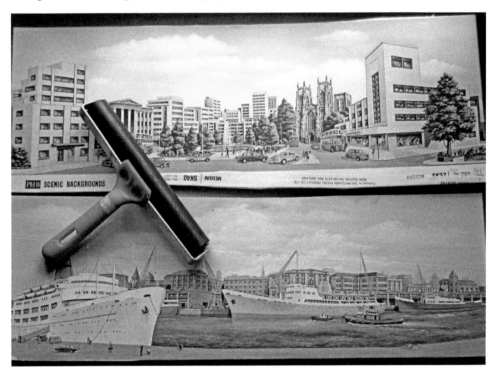

A pair of printed Peco backscenes mounted on foamboard for strength. Each Peco design is available in three sizes. The brayer is used to roll the sheets out flat, and remove bubbles.

Glues and Paints

Because we are using a range of materials, we need a range of glues. Polystyrene cement is used for plastic kits, never expanded polystyrene foam. PVA wood-working glue is probably used the most, but it can take a long time to dry when sandwiched between sheets of EPF or foamboard. UHU is very good, and fast drying. It is excellent for card buildings. Blu-Tack is useful for holding things.

I mainly use enamel paints in modelling as these cover better than acrylics, especially on plastic. For EPF and foamcore, acrylic paints are the only option, as enamels will melt these materials. Always clean your brushes thoroughly after use, and they will last longer. For painting clouds or large areas of distant foliage, a piece of sponge is very good. Make sure you always use sponges kept just for painting, and not something that has soaked up a range of household chemicals from the kitchen or bathroom.

Some models and props will look out of place if they are too clean. Modellers often use paint and pastel powders to artificially age models and buildings. This is called weathering, but should not be overdone. Dry brushing is one of the most common painting techniques for weathering and bringing out detail. Once a model has been painted, allow it to dry thoroughly. Dip an old paint brush in the chosen weathering colour – muddy brown, light dusty brown, sand, or a lightened 'faded' version of the main colour – then wipe most of the paint off on a rag and flick the brush lightly over the model so only a little paint is applied. Do this carefully and your models will indeed look centuries old. Never use a good brush for this, as the technique will quickly ruin them.

Storage

Every modeller needs a spare box or boxes in which to keep leftover kit parts and offcuts of card or foamboard. These will all be useful for future projects. Use old kit boxes, shoe boxes, or the chests of mini drawers sold in hardware and craft shops.

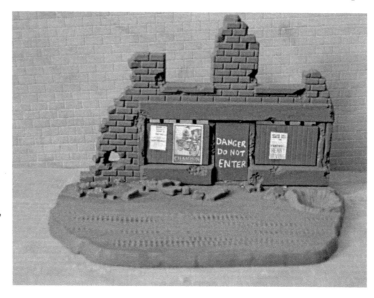

A small scenic base from a model tank kit, a section of damaged wall from another kit, boarded up windows from lengths of planking, and some paper model railway posters. Leftover kit parts should always be kept for future projects like this.

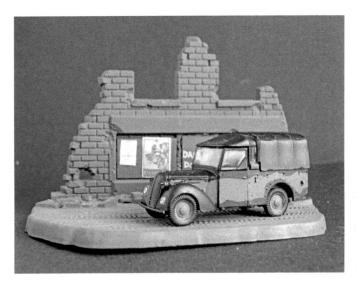

Austin Utility, or 'Tilly', from the Airfix RAF Bomber Resupply set, posed on a base made up from left over kit parts. The dark grey background is actually two sheets of black paper.

Trees, foliage, and loose scatter materials can be kept in plastic icecream containers; these are a good size, stack easily, and are free. Mounted backscenes need to be kept flat, while things like grass mats are best kept rolled up, in the corner of a cupboard. Dust is our biggest enemy, so keep larger items such as hills in plastic bags.

Real Backgrounds

Some models can be posed with part of the real world as a background. There are several reasons why I do not do this. It means venturing outdoors; the available backgrounds will be limited, and may be badly out of scale with the model, and there may be objects such as buildings or modern street lights, which would be out of place for many subjects. Shooting indoors on a tabletop gives you complete control of everything.

Backscenes

These add depth, without taking up any space. If the backscenes are separate from the foreground, you can mix and match, creating more variety. The simplest backscene is a sheet of plain blue card, representing the sky. Clouds – white and fluffy, or dark and stormy – can be added by dabbing on white or white and grey paint with a piece of sponge or large brush. If the two colours are applied together, the wet paint will merge, creating a softer look than if the first colour is allowed to dry before applying the second. Distant hills can be suggested with a wavy green line, streaking on various shades. Mountains are taller than hills, and more jagged; perhaps with snow-capped peaks. Again, a piece of sponge is ideal. Trees are simple blobs of green – vary the height and colour for a more natural look. No artistic skill is required for these simple backgrounds, and they will be partly hidden by the models, trees, and other items in the foreground anyway, so often they will be hardly visible. You can control how sharp or blurred the background appears, without adjusting the camera settings. Sheets of

cardboard or foamboard can be dabbed and streaked with various colours to create an out of focus look, even when the background is perfectly focused. A green/grey/ brown/sandy mottle will vaguely suggest foliage; while various greys and browns might suggest rocky terrain. Sometimes you might actually want the subject to partly disappear against the background, such as a tank or a wild animal, to show how effective the camouflage is, but you do not want to completely lose the model, or all you will be left with is a photo of some model trees.

Instant clouds: a sheet of light blue card, dabbed with white and grey paint – either a brush or a piece of sponge can be used.

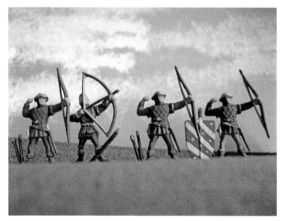

A group of English archers engage the French, their bases hidden by a convenient fold in the ground. These Revell figures measure just 25 mm from the soles of their feet to the tops of their heads.

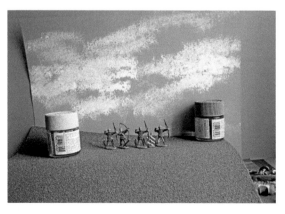

A sponge-painted sky provides a simple background for any type of model. Weights are often needed to hold things in place, such as these jars of paint.

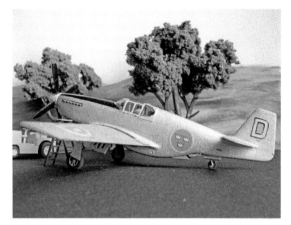

Many Allied and Axis aircraft ended up in Neutral counties during the Second World War, including this early P-51 Mustang that landed in Sweden. The plane is an Airfix kit, but finished in leftover markings from another kit. Note the sky does not completely fill the upper right corner of the shot.

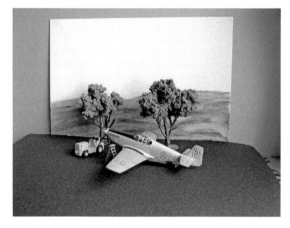

Black paper, two model trees, and a backscene consisting of streaked-on green hills. The small tractor was included in an old aircraft kit, while the ladder is from the Airfix RAF Bomber Resupply set.

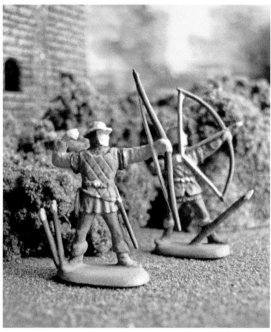

Bowmen in action beneath the walls of a ruined tower. It is not necessary to show the whole tower, just part of one wall is enough to set the scene.

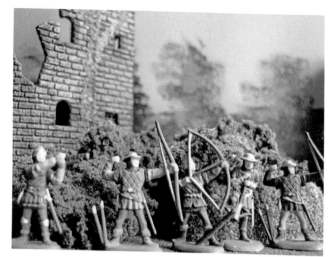

Revell English Foot Soldiers take up position in front of a ruined tower. The bushes behind them are pieces of loose clump foliage and a small hill, while the distant trees are painted on to the sky with a sponge.

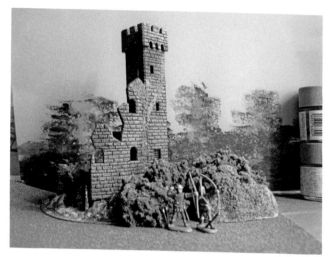

The ground is a grass mat, with various items of foliage, the ruined tower, and a painted backdrop – the trees were dabbed on with a sponge using various shades of green. The paint jars are to prevent the sky from falling over.

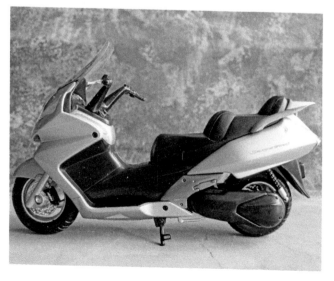

Large-scale motor scooter on a simple painted base. The seemingly out of focus foliage in the background is actually in focus – it has been sponged on using several shades of green.

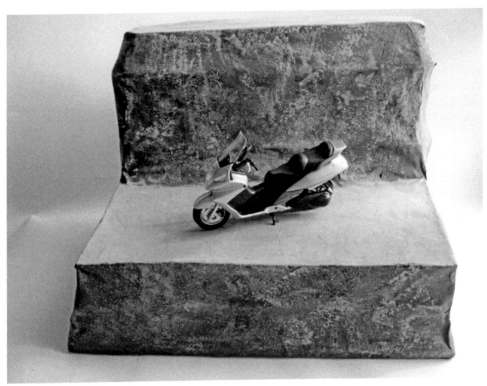

Roadway and hillside made from egg cartons covered with strips of heavy brown paper torn into strips. This time there is no texture; paint has simply been applied with a sponge, giving a soft background that will not distract from the subject.

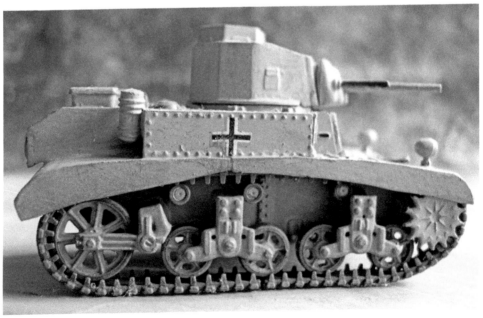

A captured Stuart light tank in German markings, on the same egg carton roadway as the motor scooter. The patchy green background gives the impression of distant foliage.

Printed backscenes are also available. Intended to go at the back of a model railway layout, they actually provide excellent backgrounds for any type of model. The same design may come in various sizes to match the main model railway scales. Most backscenes are printed versions of a painted original, but photographic scenes are becoming more common. I am not really sure if this works. Putting a model in front of a realistic photographic background can make the model look artificial and out of place. The backscenes I use are by the British company Peco, and have been available for many

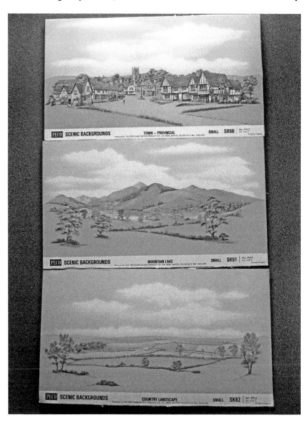

Three small Peco backscenes, mounted on foamboard, and ready for use.

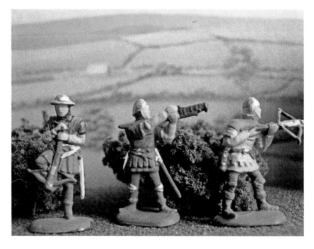

Crossbowmen and hand-gunners in action, in front of a Peco backscene; with grass mat, and Woodland Scenics clump foliage. This backscene is suitable for use with such models, but some might contain modern elements that would need to be hidden by trees or buildings.

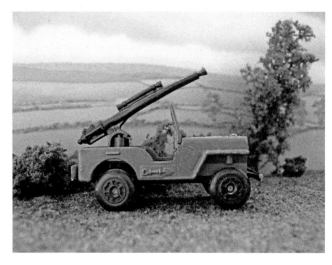

Matchbox Jeep with recoilless gun. Grass-covered plank and Peco backscene, this time with some foliage in the background.

The Matchbox Jeep set-up. Height is adjusted by using another piece of wood under the grass-covered plank.

years. Some of them contain items, such as 1960s cars, which may be out of period with the models you are trying to photograph. Here all you need to do is position the models, and perhaps a tree or some other prop, to hide the unwanted details.

Backscenes are usually printed on long strips of paper and need to be mounted to keep them flat and reduce wear. Foamboard is ideal, but warping is always a problem as the glue dries out. Brush thinned PVA glue over the back of the backscene, making sure not to miss any spots or there will be bubbles. Carefully lay the backscene down on the foamboard, then smooth it out using a brayer – a roller available in art shops. If any glue seeps out, wipe it off with a damp cloth. Cover the backscene with sheets of waxed kitchen paper – wax-side down, to prevent things sticking together – and put something heavy on top to keep it flat. Leave for several days while the glue dries.

A wall, fence, hedge, or even just a pile of loose clump foliage is a good way to disguise the sudden transition between the three dimensional foreground and the two dimensional printed or painted backscene. A small hill, or a stand of trees will do the same thing.

Roads

Any grey or brown painted surface can be a roadway, with the colours streaked on to prevent a uniform look. Even a plain sheet of heavy grey or brown card can be dabbed with other colours, and turned into a road. Texture paints can be bought in various grades and colours in model and craft shops; these have various materials mixed into the paint. The texture paints and mediums sold in art shops are usually white, and will need painting. These should be applied to a firm surface – a board, or an old placemat with the varnish sanded off so the paint will adhere. Road surfaces can also be created with various types of fine model railway ballast; sawdust; or dried out tea leaves and coffee grounds. Apply PVA glue, sprinkle on the chosen material, and shake off the surplus (save it for next time). If there are any bare patches, just repeat the process. Fix the scatter in place with diluted PVA glue – adding a little dishwashing liquid will help it flow better. This may sound strange, but it is a proven technique among railway modellers, and has been in use for decades. Acrylic paint will also 'glue' loose materials in place. For small-scale models, such as Matchbox or Hot Wheels vehicles, tea leaves may be too coarse. Either grind them up to create a finer scatter, or use a painted surface.

New Ray Chrysler Turbine Car, modelled as a convertible. The roadway is an old placemat, covered with tea leaves; the grass verge is a kitchen scouring pad, dappled with paint.

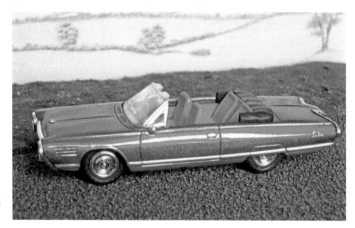

A selection of old placemats. Sand off any varnish, apply PVA glue, sprinkle on tea leaves, seal with diluted PVA, and paint. The grass verge is kitchen pot scourer, pulled in half to expose the rougher inner texture, and glued down with PVA.

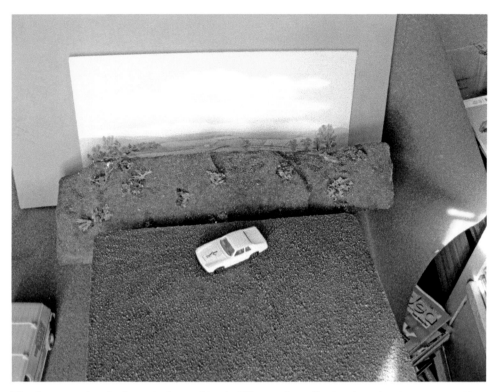

The placemat roadway has been raised up, making the hill appear lower. Keeping the various items separate allows such small adjustments to be made. Sunlight is again coming in the window, but is out of shot in the close-up.

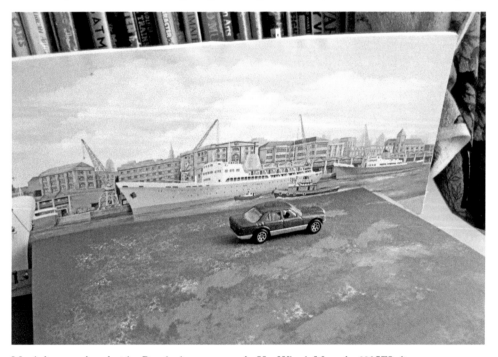

Mottled grey card used with a Peco harbour scene, and a Hot Wheels Mercedes 380SEL diecast.

Hot Wheels Ford Hot Rod. The roadway consists of tea leaves on a placemat, and a plain blue card for the sky.

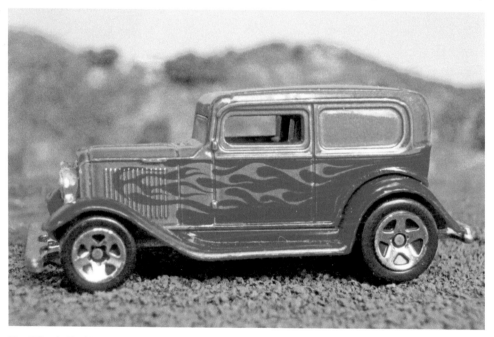

Hot Wheels Ford Hot Rod on a placemat. The tea leaves are probably a little coarse for such a small model, but could be ground up to make them finer. The out of focus hill is just behind the model.

Brick Papers

This is a generic term for paper or thin card printed with brick, stone, roofing tile, or paving stone designs, in full colour. Some even come with a 'weathered' look. Some of the sheets produced by European companies are embossed, giving a slight three-dimensional effect. Such papers are used mainly by railway modellers to make model buildings. Larger-scale papers are used in dolls house modelling. Moulded plastic card is also available in many

A selection of 'brick papers' used by railway modellers for making buildings. Printed in colour on paper or light card there are brick, roofing tile, and paving stone designs. The sheets are best mounted on heavy card or foamboard to ensure a long life.

Several small sheets of Metcalf paving stones being glued to a piece of wood. A large grass mat makes a good general-purpose background.

Sheets of textured plastic card come in a wide variety of surface finishes, but need to be painted and weathered to give them a realistic finish. Most will still need to be mounted.

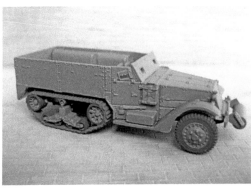

US Army M3 half track troop carrier. The groundwork is a sheet of thin plastic card with a moulded concrete block pattern, mounted on a rigid base, and painted a dirty light grey. The background is identical, but painted a dirty sand.

different designs, but will need painting. Some of the sheets sold with stone or concrete block patterns also make good road surfaces. To prevent curling, these sheets will need to be glued to something rigid, just as we did for the backscenes. Walls can be made by gluing brick or stone pattern papers over a strip of balsa wood or foamboard.

Hills

Expanded polystyrene foam is used for making hills and mountains. It is very lightweight and easy to carve with a knife or hacksaw. It is also very messy, and crumbles easily; the small plastic beads cling to everything. Either keep a vacuum cleaner handy, or try to do your cutting inside a large, clear plastic bag (so you can see what you are doing), and use a really sharp knife to cut the foam. EPF comes in sheets, blocks, and various strange shapes. It is used for packing all manner of delicate goods. If you do not have any lying around, shops throw out vast amounts, and most will be happy to give you as much as you want. Model shops also sell it for landscaping. Various insulation and florist foams can also be used. These are usually denser and stronger than packaging foam, but you will likely have to pay for them.

An expanded polystyrene foam hill under construction. Carve the foam to rough shape with a knife, cover with strips of torn paper to seal the cut foam, and apply egg carton papier-mâché for texture.

EPF hill covered in egg carton papier-mâché, painted with PVA glue, and sprinkled with dried tea leaves. If there are any bare patches, apply more glue and tea leaves.

Hillside covered in tea leaves: sealed with diluted PVA, painted with several greens to break up the uniform colour, and dry-brushed with lighter shades. Bushes can be added if required.

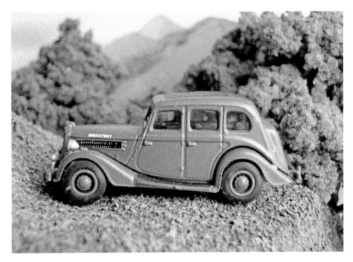

Oxford Diecast British Army staff car in 1:76 scale. The hill is EPF covered in tea leaves, Woodland Scenics trees, and a Peco backscene.

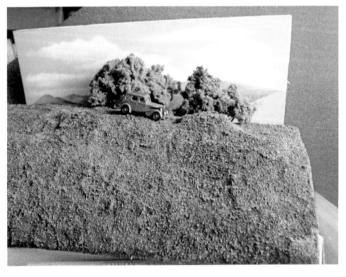

Our polystyrene foam and tea leaf hill, Woodland Scenics trees, and a Peco backscene, with an Oxford Diecast car. Posing models on such an uneven surface can be a problem, unless level spots are included.

Never try to use polystyrene model cement with EPF – it will simply melt. PVA, also known as white glue or Elmer's Glue, is good, but can take a long time to dry. You can also use UHU glue. Several thin sheets can be laminated together to make a hill. It is best to cover the foam with paper strips dipped in PVA, to seal and protect it, or the plaster-impregnated bandage available in model and craft shops. Only use acrylic paints with EPF.

Foamcore board or foamboard is a thin, dense plastic foam sandwiched between two sheets of paper or light card. Some also have a plastic coating on top. It usually comes in 5-mm or 10-mm sheets. Shops use it for signs, and then throw it away. This means a regular supply of foamboard for modelling purposes. It is a wild extravagance to actually buy your foamboard, but if you do it is available in stationery shops. For hills several sheets of foamboard will have to be laminated together, but it cuts much more cleanly than EPF. Remember to put something heavy on top to prevent warping. As the hill itself will be covered, and therefore hidden, it does not really matter what is used; all that is required is an irregular shape. Glues and paints are the same as for EPF. Egg cartons, or anything similar, are another alternative. Model railway tunnels can also be used as hills.

Papier-mâché is good for making rough ground, rocky outcrops, and other irregular shapes. Making papier-mâché from old newspapers is messy, because of the ink, but there is a cleaner alternative. Egg cartons, and the trays used in boxes to hold fruit and wine bottles, are made from a very soft, moulded cardboard pulp. This can be quickly returned to its pulp state by tearing up the trays, soaking them in hot water for a few minutes, and dipping them in PVA glue, then applying them to a suitable support. Do not make the papier-mâché layers too thick or they will take too long to dry. Paint, and apply various scatter materials. Readymade papier-mâché, often already mixed with glue, can be bought in art shops, but this is going to be more expensive than making your own.

If you want to pose models on a hill, rather than just use it as a backdrop, there will need to be some flat spots large enough for the models, or you can include a section of roadway. The fact that there are completely flat spots can be hidden with a few well placed bushes or trees. A full-size hill becomes a low mound when used with large-scale toy animals; or virtually a mountain with small-scale models.

EPF sheet, an egg carton, and paper towel roll. These can be covered with strips of torn paper, or papier-mâché, to create roadways and a hillside.

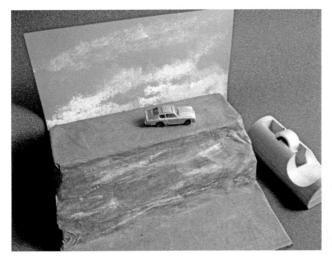

The finished egg carton hill and roadway, covered with strips of torn paper, painted with streaks of green. The sky is blue card with white paint.

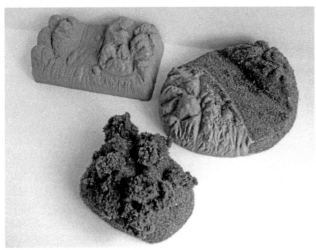

From a set of cheap toy soldiers, a selection of small plastic hills. Painted and covered in grass and clump foliage bushes, these are very useful background items.

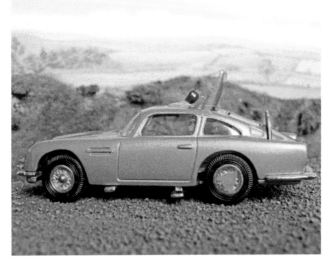

A wall, line of trees, or a hill provides a gentle transition between the foreground and the flat backscene. The hill is covered in model railway grass, and a few bushes.

Trees

Trees can be bought, made, or assembled from tree kits. As this can be rather tedious, I usually buy mine, although good quality trees can be expensive. A mix of sizes and colours is best, as it will help to break up the background. You do not really need a large number of trees to create the impression of a forest behind your models. A simple green background mass can be created with a pile of commercial clump foliage, or a torn up sponge covered in scatter, perhaps with a few model trees in front. Even model palm trees are available, although they can be hard to find. These usually have plastic or paper fronds.

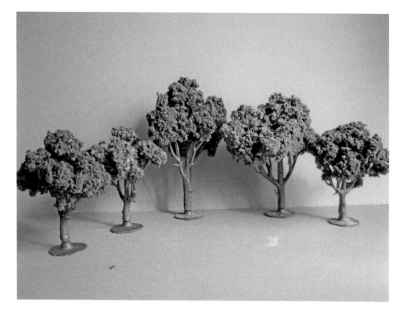

Ready-made model trees by Woodland Scenics, in various sizes and colours. The plastic trunks and foliage are also available in kit form so you can make your own.

A Corgi Junior Jaguar XJS on a grass-covered base, with clump foliage and tree branches to the rear, in front of a Peco backscene.

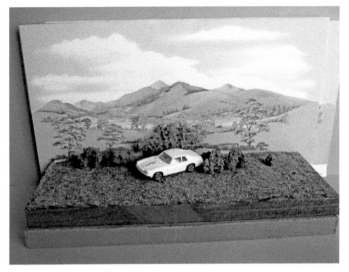

This wooden board has been covered in egg carton papier-mâché, and model railway grass. For small models this is all that is needed to create a complete miniature world.

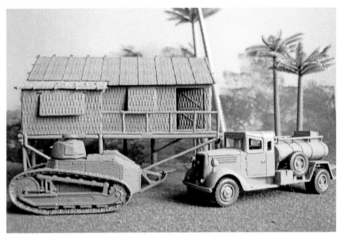

Grass mat, Airfix Jungle Outpost hut, with plastic palm trees to the side, and painted trees in the distance – all suggesting the Far East. The vehicles are both built from kits.

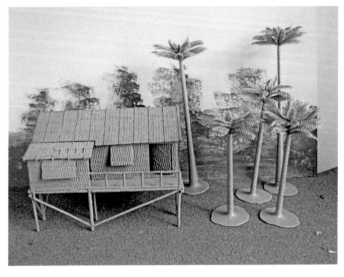

Among the more exotic plastic building kits that have been released is the Airfix Jungle Outpost; versions being produced in 1:72 and 1:32 scales. The palm trees are by the American company Woodland Scenics. They really do need to be painted, and their bases disguised.

Making foliage

Model shops, particularly those specialising in model railways, carry a vast range of materials for making grass, bushes, and trees. Most come in a range of colours, including autumn shades. Quality varies, with some brands using rather garish colours. The American Woodland Scenics range, aimed at railway modellers, is very good. If you do not live near a model shop, there are alternatives; we simply have to go back to the days before ready-made commercial products, and make our own.

Scatter materials, for making grass and the leaves on trees, may be called turf or fine foliage, as well as grass. These are sold in bags and jars. Some are a single colour; others are a mix of shades, and these tend to be more realistic. Coloured scatters are available to depict flowers. These are often made from finely ground up foam, although dyed sawdust was once popular. This can still be used to make your own scatters, but I do not have a ready supply of sawdust. As an alternative, I use dried out tea leaves or coffee grounds. Paint the ground an earth or green colour, brush PVA glue over the area to be covered with grass, and sprinkle on your scatters. Once dry, tap to remove any excess, and fix in place with diluted PVA – just as we did when making roads, only this time the scatters are painted green – but use an old brush as the uneven surface of the tea leaves is very tough on brushes. To avoid the grass looking like a carpet, dapple on another green to break up its uniform appearance. Then dry brush on another, lighter green, to bring out the texture.

Buildings

Most model railway buildings are intended to sit on a layout and receive very little handling. Because the buildings we will be using as photographic props will be handled, they will often need to be strengthened internally with card, balsa wood, or plastic card. Leftovers from other projects will often do the job without cost.

A pair of Superquick low-relief buildings from the rear – the structure on the right has had extra pieces of scrap card glued inside for strength.

There are two types of buildings: full models, with both a front and a back; and half- or low-relief buildings, comprising only the front or the back. This allows them to sit at the back of a railway layout without taking up too much space. We can use either. Buildings aimed at military modellers and wargamers frequently show the scars of battle, which will suit some models more than others.

Card building kits have one major advantage over plastic kits – they do not need painting, but you are limited to the colours chosen by the kit maker. Sometimes there are alternative doors in different colours, or shop signs, so some variation is possible. The weight of card used varies. The term 'paper engineering' really does apply to the British-made Metcalf models. They are heavy, robust, and have very clear instructions. They are expensive, but you are paying for the best. Next there is Superquick, which have been around a long time, and come on fairly thick card. A little extra reinforcing at the corners, and extra internal floors, will make them even stronger. Builder Plus use a much lighter card, and these really do need extra internal supports. All of these models are aimed at railway modellers, and are made to normal model railway scales. Usborne in Britain, and Dover Publications in the US, publish a wide range of books containing

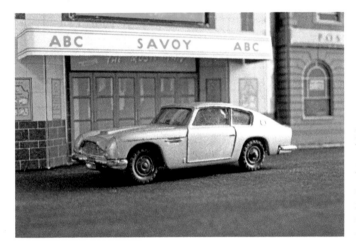

Husky Aston Martin on a black paper roadway, with Superquick low-relief card buildings. A piece of white card to the left of the model reflects light on to the front of the car, which would otherwise be in shadow.

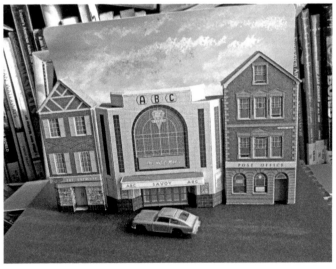

The road is just a sheet of black paper, which will appear dark grey and a line of Superquick low-relief buildings (all from one kit); the sky was not needed for this shot. The bookshelf will not be visible in close-up.

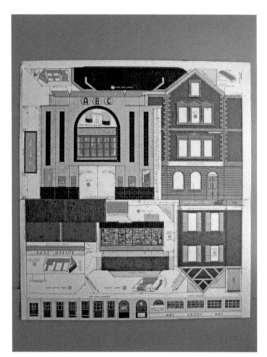

A typical card building kit: the Superquick low-relief cinema and shops, printed in full colour. The parts are already partially cut out.

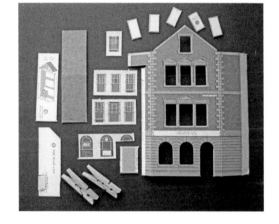

Most of the parts for the Superquick Post Office laid out on a sheet of black paper. Punched-out windows and other scrap card can be used to reinforce the model, allowing it to stand up to more handling than a normal model railway building.

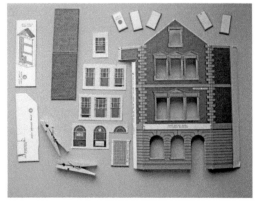

The same parts laid out on yellow card. They stand out well against either background, and it is really a matter of which you prefer.

Kit parts arranged on a file box, which provides a simple background. Mini clothes pegs, used for craftwork, are useful for holding parts together while the glue dries.

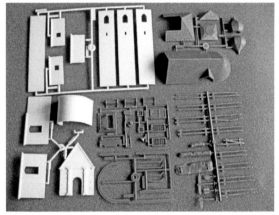

Many building kits are moulded in self-coloured plastic, but it is always best to paint such models to protect the plastic, and give a matt finish. This is a small Kibri church kit, with a very exotic roof design. The parts are laid out on a grass mat, and are still attached to the sprue.

cardboard cut-out building kits aimed at children. These range from ancient Roman and medieval buildings to a Wild West town, and various everyday buildings. They are printed on very light card, which would need to be glued to something heavier, and scales vary. Some are printed on gloss card, which could cause problems with reflections. These kits could easily be converted to low-relief models by simply cutting them in half, and adding extra internal bracing.

Some plastic kits are moulded in one colour and will need painting. Others, mainly those from Europe or the USA, come moulded in several colours. In theory these do not need painting, but unpainted plastic always has a slight sheen, it attracts dust, becomes brittle with age, and the light colours are especially prone to discolouring. I always paint mine with matt enamels or acrylics, and add a little weathering to age them. Fully assembled plastic buildings are also available. Ready-made resin or plaster buildings have become popular in recent years, painted or unpainted. These are usually expensive, but most will require no work beyond taking them out of the box.

Certain buildings are especially useful for showing off certain types of model: a hangar for model aircraft; a bus depot for buses and coaches; a service station for cars; or a barn for tractors, farm machinery, and animals. A row of shops or houses makes a good general background, suitable for almost any type of vehicle. A castle or cathedral makes a large and dramatic backdrop, but such models tend to be rare, expensive, and difficult to store. A ruin is usually a lot more compact, and just as dramatic.

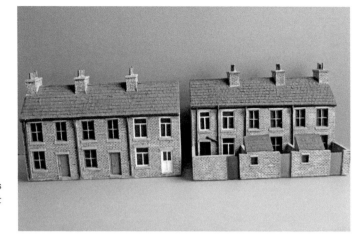

A pair of OO (1:76 scale) model railway buildings in resin from the Scenix range, which come fully painted. These are complete buildings with both front and back, but low-relief versions are also available.

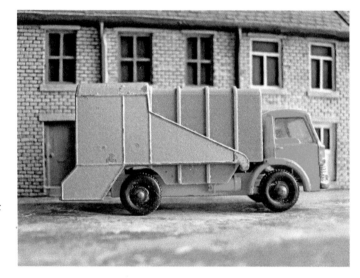

A Matchbox Rubbish Truck on its rounds. Some model rubbish bins could be put out ready for collection – these are available in a number of model railway accessory ranges.

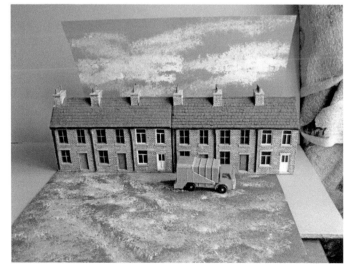

Two resin buildings are enough to create a whole miniature street, and will not take up too much space. The road is dark grey card mottled with light grey.

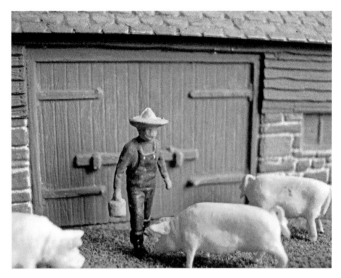

This farmer is about to feed his pigs, although the area around a barn would probably not be well-mown grass, so this needs changing.

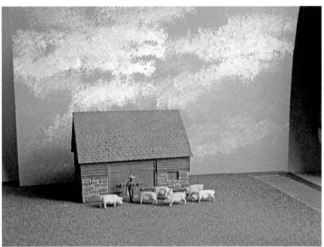

The barn is a simple plastic kit by Wills and is intended as a model railway accessory, as are the farmer and his livestock – the pigs are only 20 mm long.

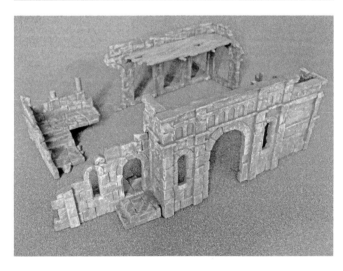

From a wargaming shop, these Ruins of Osgiliath are part of a *Lord of the Rings* range. They come in kit form and are moulded in heavy grey plastic. Ruins always make good backdrops, and do not take up as much space as complete buildings.

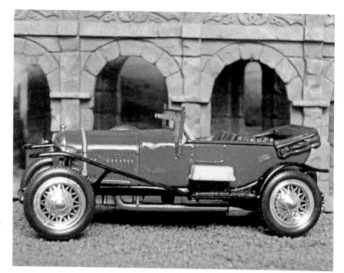

To fill up the interior of the ruin, a second wall section is placed behind the first, allowing only a glimpse of the distant hills.

Corgi vintage Bentley. The ruins are painted dark grey, and streaked with various lighter shades of grey and grey-green to break up the solid colour. The road is made from tea leaves, and the hills are streaked on to a piece of blue card.

Street Furniture

This is the odd term used for items that fill up the streets around us: street lights, letter boxes, telephone kiosks, litter bins, and all manner of signs. All are available as models, in metal or plastic; some of them ready-painted. Small-scale items are usually aimed at railway modellers, while those in the larger scales are intended more for diorama work, and are aimed at military modellers. They do have their uses in model photography, but they can actually clutter up a scene if too many are used. My own preference is to keep things simple and uncluttered.

Other accessories are also available; everything from old-fashioned milk churns, oil drums, wooden crates, and piles of timber, to metal rubbish bins and wooden pallets. Some items are more common in some scales than others, but an exact match is not always needed – especially if the real thing varies. Placing smaller-scale models behind larger-scale examples also enhances the impression of distance – this is a trick used in several photos.

Matchbox SS 100 Jaguar sports car, in front of a Peco backscene. If these catch the light they can appear very washed out – tilt the scene slightly forward to avoid this.

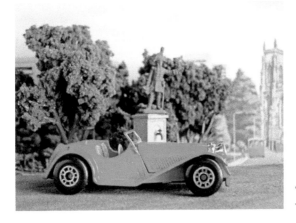

This time the backscene is only partially visible behind a statue and a row of trees.

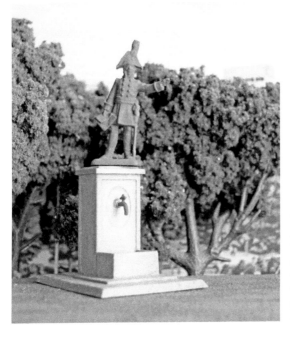

The base of the statue is a small fountain from the Italeri Urban Accessories set in 1:72 scale, aimed at military modellers. Any suitable figure can be painted dark brown – to depict weathered bronze – and placed on top. Here an officer from a set of Napoleonic figures is used. A collection of such props can be built up.

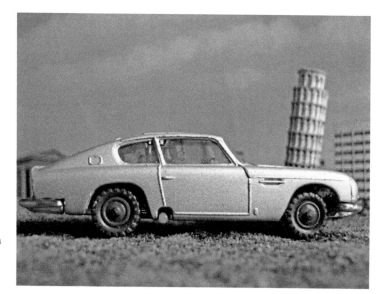

James Bond and his Husky Aston Martin on assignment in the Italian city of Pisa, with a few other local buildings visible in the distance.

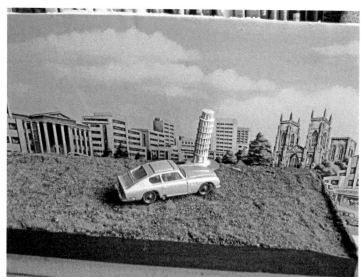

Grass-covered plank, with a tiny Leaning Tower of Pisa model. The board has been raised up, so only the tops of the buildings in the background are visible.

Railway Models

Models of locomotives, carriages, or wagons, are usually displayed on a length of straight model railway track. Most track is plain, but some comes on a plastic base, representing stone ballast. To make your own, mount a section of track on a length of wood, EPF, or foamboard, and apply model railway ballast – this comes in different grades depending on the scale of the models, and different colours. If you do not have any ballast, just use ground-up tea leaves or coffee grounds. Use a paint brush to work the ballast around the plastic sleepers, and fix in place with diluted PVA, then paint both track and ballast a dirty brown. Only the tops of the rails should be bare metal.

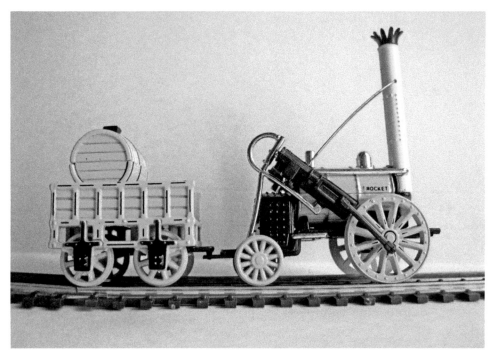

Matchbox Models of Yesteryear Stephenson's Rocket. Buff file folder, and a length of model railway track. This is actually too narrow for the model, but as long as the wheels closest to the camera are on the rails, this is not obvious.

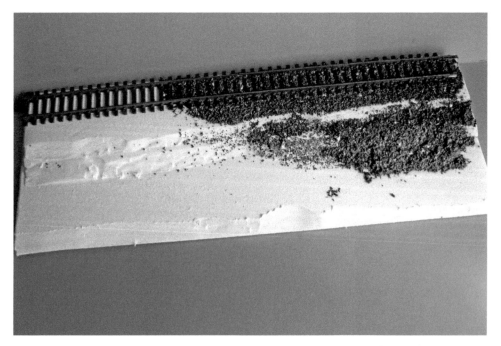

Three layers of foamboard glued together, cut to a slope, with a length of model railway track on top. Dried tea leaves are used as track ballast and grass; fixed in place with diluted PVA glue – add a little dish washing liquid to help it flow freely.

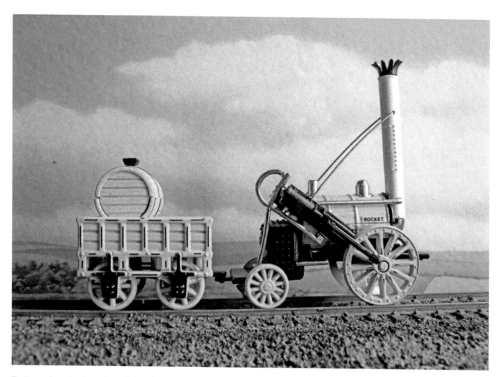

Ballasted and painted model railway track in front of a Peco backscene. The wheels of the locomotive do not sit on the track very well, and are supported at the back with small blobs of Blu-Tack.

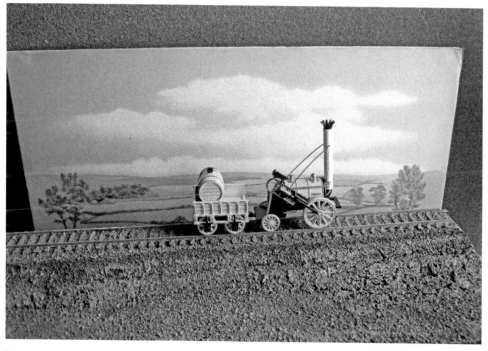

The completed section of track, mounted on foamboard. The track and ballast are painted brown, and the grass various shades of green.

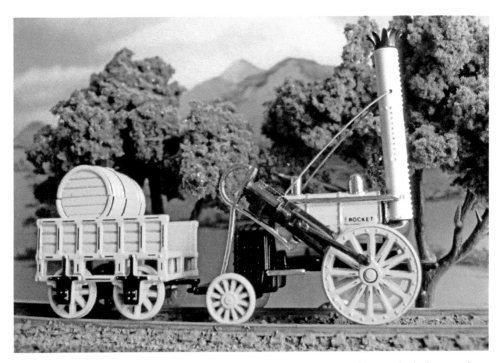

There were no photographers at the Rainhill locomotive trials in 1829, as photography had not yet been invented, but we can still record the event using models and a little bit of imagination.

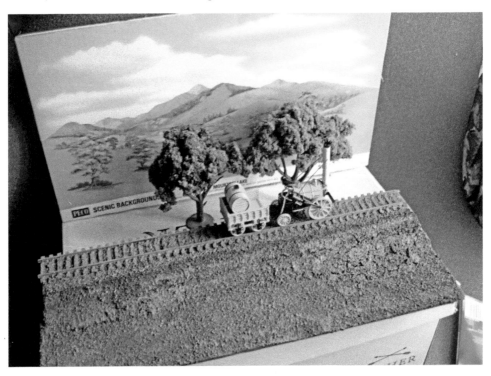

Here some trees have been added in the background, just in front of the backscene; making sure there are no unwelcome shadows. The set-up is resting on a shoebox, which brings it level with the camera lens.

Water

Real water is not really suitable for model photography. A small quantity of water in a bowl is simply not going to look like the open sea, or be the right colour. There are various ways of modelling water, but the more realistic usually involve fixing a model boat into a solid seascape. What we need is a water surface that allows different models to be displayed, and this means opting for something a little less realistic, but more practical.

How you approach photographing model boats and ships depends on whether you have a full hull or waterline model. Full hull models include the entire hull, while waterline models only show the vessel above the waterline, and omit the lower part of the hull. Waterline models will sit on any flat surface, such as a sheet of blue card, which can be used to depict calm water. Shallow and muddy waters can be represented by streaky green or brown card. To depict a full hull model at sea it will be necessary to disguise the lower hull. Crumpled crepe paper or fabric will make the sea, with a hollow for the hull. I actually found a cheap blue scarf, made from some slightly shiny ruffled fabric, which makes a passable sea. The size of the waves depends on how much you crumple up the fabric.

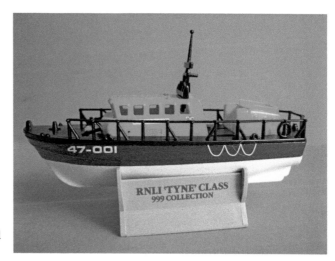

Lledo RNLI Tyne Class lifeboat. This is a full hull model, and normally sits in a plastic cradle. Depicting such models in the water is more difficult than with waterline models, as the lower hull has to be hidden.

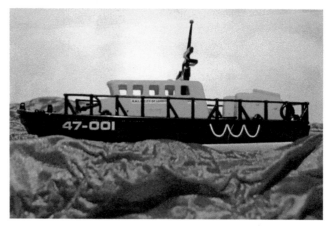

Lledo RNLI Lifeboat in a sea made from a cheap blue scarf. The sky is by Peco.

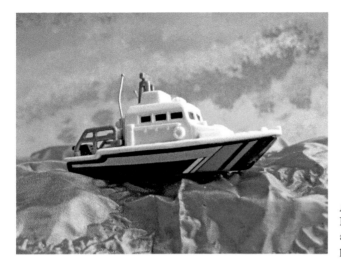

A waterline Matchbox Sea Rescue Boat on a blue scarf, which makes a passable sea; this time with a painted sky.

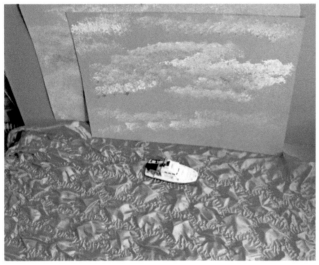

The Matchbox launch on its 'sea' – a thin blue scarf of some crinkled fabric resembling waves – with painted white and grey clouds.

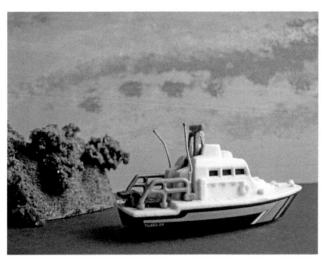

The Matchbox Sea Rescue Boat on a sea of dark blue card, a small plastic hill for an island, and a sky of light blue card with painted clouds. The boat is a waterline model, with a flat base, and runs on concealed wheels.

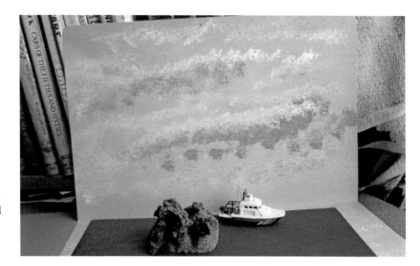

The island is a small plastic hill covered in grass and clump foliage – it could also be left bare, and painted as a rocky outcrop.

Special Props and Backgrounds

Occasionally you may need a special prop or background for a particular subject. It may be possible to find something suitable, or adapt whatever you have to hand. Sometimes there is no option but to make the item concerned, then you have to decide if the extra time and effort is worth it. Since I enjoy modelling, my answer is usually going to be 'yes'. An example of a special background are flames, which make a great backdrop for either military or emergency vehicles. They can just be painted on the backscene, which looks rather flat, or given a more three-dimensional look by building them up slightly with papier-mâché, then painting red, orange, and yellow, with billowing clouds of black smoke.

Two wooden boards covered in papier-mâché made from egg cartons. This makes both the ground work, and what will become the flames and billowing clouds of black smoke.

The papier-mâché groundwork is painted brown, covered with PVA glue, and sprinkled with blended turf – a mix of various green shades. The flames are painted yellow, orange, and red, with black smoke.

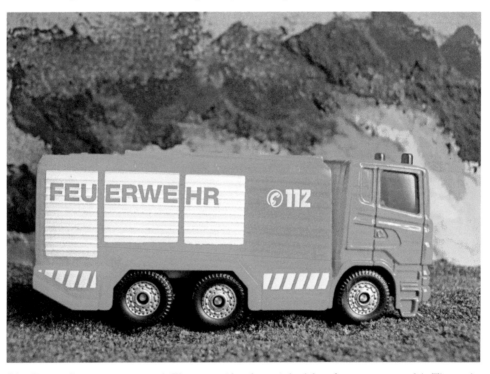

Siku German fire service rescue truck. Flames provide a dramatic backdrop for emergency models. The smoke is applied with a sponge, giving a hazy look.

Close-up Photography

Cameras come ready for use, with their controls set at the factory. Many of these can be adjusted, giving you greater control over the final photograph, but I normally leave everything on the Automatic setting. With the camera on Auto, it will do everything: measure the light; set the aperture; the exposure; and focus on the subject. Only occasionally is it necessary to change the settings for a particular shot. This means telling the camera to give priority to one aspect of the photo. The camera will still take care of all the other settings, and you can proceed as usual. You just have to remember to return the camera back to the original settings when you finish.

On the A490 this is done by pressing the small Mode button on the back of the camera, and switching from Auto (Automatic) to P (Program Auto Exposure), but on some cameras the change would be made using the Menu button. My A490 has many features I have never used, but you can experiment with the various controls if you like. Once the setting you want is selected, press the large Function Set button on the back of the camera to actually set it. It is best to keep a note of what the original settings are when you change anything, so you can return to them. In case you forget there will be a Default button somewhere, to return the camera to its factory settings. To increase the depth of field, and therefore the portion of the photograph in focus, you can set the aperture to its smallest setting, and the camera will adjust the exposure time to suit.

There are a large number of symbols that can appear on the screen or in the viewfinder, giving you all sorts of information. This display can be turned off if you find it distracting, but some of the information is actually useful, such as the shutter speed. The camera may also make various warning sounds; again, these can be turned off if you want. To check the photos you have already taken, press the Playback button to bring up the last shot. Pressing the left and right arrow buttons will allow you to search through all the photos on the camera. Pressing the zoom button while in Playback will fill the display screen with an increasing or decreasing number of small shots, rather than one large one. Pressing the Playback button again takes you back to shooting mode. Get to know your own camera, exactly what features it has, which buttons you need to be concerned with, and which you can ignore.

With some cameras, various filters can be screwed on to the front of the main lens – assuming the lens has the necessary screw thread. There are many different types of filter; some reduce glare, or adjust the colour. There are also close-up lenses, used to magnify objects. The strength of these close-up lenses is measured in dioptres, starting with +1. Several lenses can be used together, so a +1 and a +2 lens can be combined, which saves you having to buy a +3 lens. None of this applies to the Canon A490 used here.

Taking Pictures

There are a number of specialist books available on photographing particular full-size subjects: aircraft, cars, trains, pets, and wild animals. Some of this advice may be applicable to models, suitably scaled down. As usual with photography books, a lot of the material is very complicated and technical, but the photographs themselves may give you some ideas. Study photographs of the real thing, and try to duplicate their look in miniature.

Not every model photograph you take is going to come out perfectly, but even if you only get one or two good shots from your first few attempts, these shots will be magical and well worth the effort. As you gain experience, the number of good shots will increase. It is generally easier to photograph a large model than a small one, so start out with something fairly large, and then move on to smaller models. Large-scale

Card roadway, upper portion of a Peco backscene, and a crash barrier made of old tyres – wheels from a plastic kit. Sometimes it is worth buying a kit just to obtain a supply of useful parts.

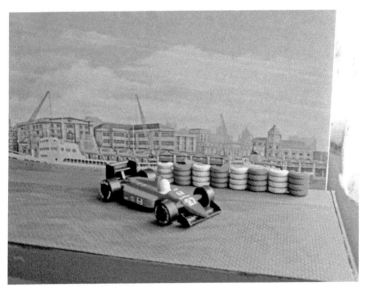

A plank covered in plastic card, with a paving stone pattern. The tyre crash barrier is made from the wheels in an Airfix kit, cut in half to double their number, and glued together with a strip of plastic card at the back for strength. These barriers are frequently painted in alternating high-visibility colours.

figures, either human or animal, dolls, teddy bears, action figures and toy robots can all be treated as if they were full-size humans when it comes to portrait photography.

Over the years I have developed my own methods of working, which suit me, but a different approach may suit you better. Experiment and find what works for you. Sometimes a particular set-up does not work as well as you expected, and it may be necessary to try a number of ideas to find a solution. The James Bond Lotus Esprit submarine car from the film *The Spy Who Loved Me* (1977) just had to be photographed in an underwater setting, but finding the right background to give the shot an underwater feel was a matter of trial and error.

To take a good photograph of a small model, it must first be isolated from its normal surroundings. Our full-sized world must not intrude. The easiest way to do this is simply use a large piece of white or plain-coloured card or paper as a background. If the card is large enough it can be placed under the model and curved up behind it so the background is completely smooth. Hold the card in place with a weight at each corner. This is the way a professional photographer would do it; but what if the only card you have to hand is not large enough? Options include: finding or buying a bigger piece of card; using two pieces instead of one; a coloured file folder opened out (these are available singly, or in packs of assorted colours); the back of an old boardgame board; a roll of wallpaper; a large piece of smooth non-shiny fabric; or a grass mat. A grass mat is a sheet of paper, plastic, or fabric with a grass-like covering. It is used by railway modellers to quickly cover large areas of a layout and can be bought in different sizes, from small sheets to large rolls. Mine is a roll of ReadyGrass by Woodland Scenics, and measures 33 inches by 50 inches (838 mm by 1270 mm), which is big enough for most jobs. The next size up is 50 inches by 100 inches (1270 mm by 2540 mm), which might actually be a little too large for the average tabletop. Different shades of plain green are available as well as mixed spring and summer varieties, which are more realistic than a single colour. The major problem with grass mats is that most are very neat, and depict a well-cared-for lawn, rather than anything wild. Loose bits of clump foliage or pieces of sponge dipped in green scatter will help break up large areas. Some grass mats also shed their grass material very easily, but Woodland Scenics is a good quality brand, and I have had no problems with their ReadyGrass.

You can get started with model photography using just a few sheets of coloured cardboard or heavy paper for backgrounds. A pack of scrapbooking (photo album) pages in various muted or 'natural' colours is useful, but avoid anything with even a slight sheen – these will catch and reflect light. Use only matt papers. The standard size for photo scrapbooks is 12 inches (30 centimetres) square. Photo albums and some scrapbooks have matt black pages, which will photograph as dark grey – these make very good roads, or even general backgrounds. Heavy, coloured paper is also sold in art shops for use with pastels, often in pads with a selection of colours. Any of these can have distant hills or trees painted on them. Mottled and marbled papers are also available.

When cataloguing your collection, making records for insurance, or trying to sell items online, the main requirement is clear photographs that show the model from several angles; front, rear, both sides, top, and underside. Any working or opening features should be shown both open and closed. Sometimes this will include groups or sets. Do not forget the box; again, both front and rear. This will clearly show the condition of both the model and its packaging. When photographing the raised or indented lettering on the underside of a model, it is best to have the model at an angle to the light so the letters cast a slight shadow, helping them to stand out.

Tamiya German King Tiger tank in 1:35 scale; the turret of this monster alone is bigger than many 1:76 scale models. Close-up shots are easier with large scale models, but you may have to move further back from the model, meaning a larger table is required.

The background is nearly big enough for the model, except in one corner. Including a model crewman shows just how large this tank was.

The bigger the model, the larger the background will need to be – this sheet of blue card would have been large enough for a 1:76 scale model.

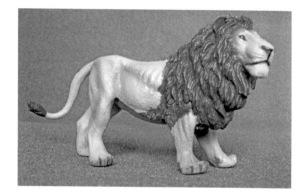

Even against a plain grass mat this plastic toy lion looks impressive. Nose to tail he measures 140 mm.

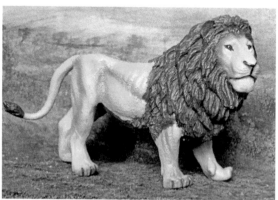

Even a very simple painted background makes this lion look more at home. A piece of coloured card is finished with streaks and blobs of green and brown paint. It is not intended to be anything specific, and a background such as this requires no painting skill at all.

A patch of rough ground, with a vague suggestion of foliage in the distance, will provide a suitable setting for almost any type of model.

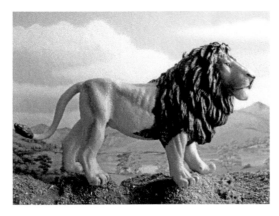

With his feet barely touching the uneven hilltop, this lion looks as though he is floating in mid-air.

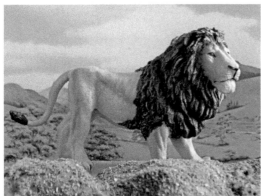

Left: The lion now stands on a small block of wood, hidden behind the hill, and is no longer levitating.

Below: The height of models can be adjusted by using small blocks of wood or other items. The hill is EPF, covered in plaster bandage and model railway grass.

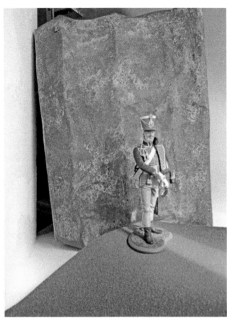

Above left: Some figures are so large they can be treated as real people, as far as portrait photography is concerned. The same would apply to dolls or teddy bears.

Above right: Even the back of a hill can be painted, allowing either side to be used as a backdrop. Again, various greens have been applied with a sponge, giving a very soft finish.

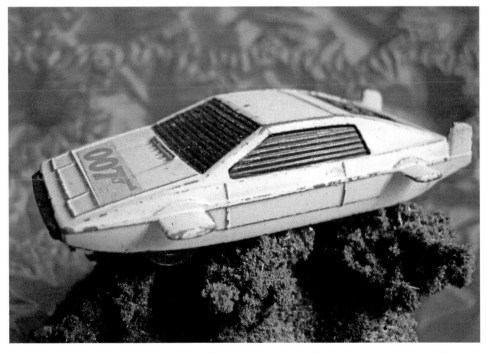

Corgi Junior Lotus Esprit submarine car posed atop a bush-covered hill – or seaweed-covered rock. The scarf previously used for the sea really does not make a very convincing underwater background.

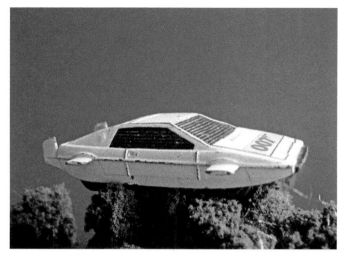

The Bond Esprit with a dark blue card background. Packs of 12 inch/30 centimetre square scrapbook papers are ideal for use with smaller models.

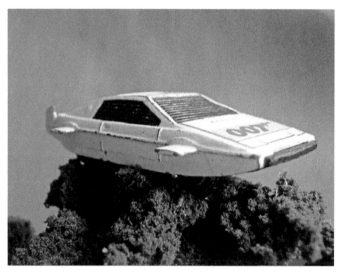

Thin yellow-green fabric proved to give the best 'underwater' look. The Bond Esprit is actually resting on the seaweed-covered mound.

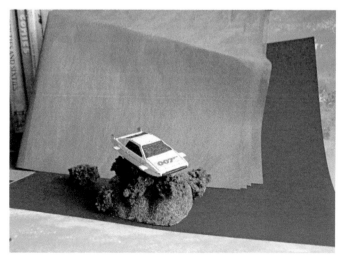

Sometimes it is necessary to experiment to achieve the best results; here a selection of different backgrounds are being tested to see which provides the best 'underwater' backdrop for a Corgi model.

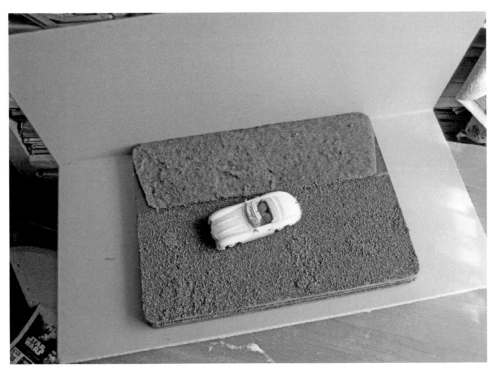

An old boardgame board sits on top of a small folding table by a window, supported by a bookshelf – this is all the 'studio' you need. All the photographs in this book were taken with this set-up.

Matchbox Chrysler Atlantic concept car. Even a piece of rough grey cardboard can be streaked with paint to resemble weathered concrete. Road markings could also be added.

Hot Wheels Lamborghini. Now we are up to two pieces of painted card. Grey roadway streaked with paint, and thin streaked-on hills for the background.

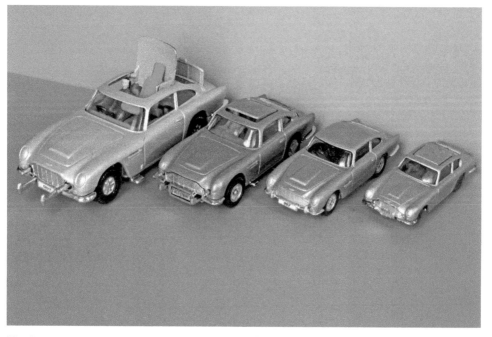

The Corgi James Bond Aston Marin has been produced in several sizes over the years, this shot showing how they compare. The plain background is an old boardgame board, which is very sturdy.

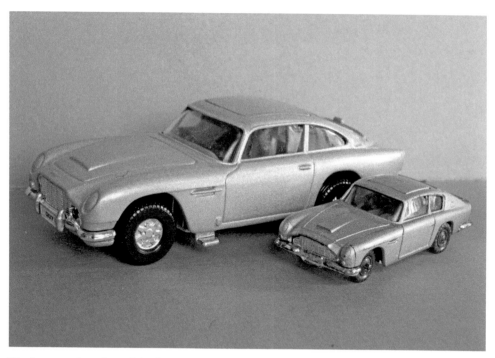

The largest and smallest of the Corgi Aston Martins. A shot like this benefits from a totally uncluttered background.

Siku US Fire Chief's car, with opening doors. Thin sheets of plastic card must be glued to a support for strength; they can then be painted light grey or sand, and wiped over with another colour. One sheet provides the roadway, the other the background.

Models arranged in front of the box, showing that the contents and box top illustration match. This shot again uses a plain background.

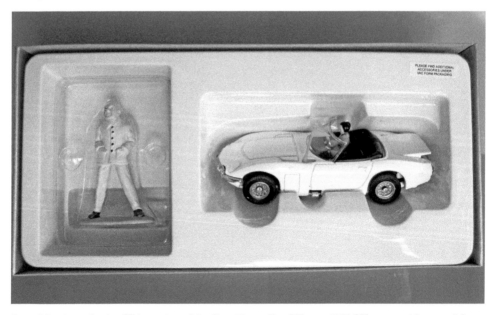

A model in its packaging. This version of the Corgi James Bond Toyota 2000GT comes with a metal figure of villain Blofeld. Clear plastic inserts hold the models in place, but remove these for photography, to avoid reflections. Shots like this tell a potential internet buyer exactly what is in the box, and what condition the models and box are in.

When selling online, even the back of the box should be shown, as this helps to identify the model and show the condition of the packaging.

Japanese company Tomy produce a number of unusual models, including this animal carrier truck containing two plastic pandas. Posing a model on top of its box is a good way to show both at the same time, and depth of field is less of a problem.

The underside of a diecast model. The cast-in lettering tells us this is a Corgi Mini Bus, and it was 'Made in Gt Britain'. The lettering is only slightly raised, and the light needs to be from the side, to cast a slight shadow.

For some items it will be impossible to remove the model from its packaging without damaging the box or card. These models must be photographed while still sealed. With plastic packaging – such as the bubble packs used for many small diecasts i.e. Hot Wheels, etc. – reflections are a problem. Adjust the model and camera to reduce them, or use a plain card off to one side to block out whatever is being reflected. Many of the models aimed at collectors come in rigid plastic display cases. The clear top is usually just clipped to the coloured base, and can be carefully removed to make photography easier.

Some models will have to be photographed while still in their packaging; adjusting both the camera and the model to reduce reflections.

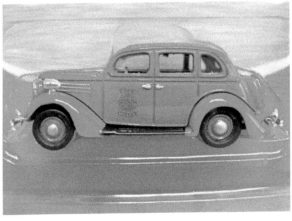

It is even possible to get close-ups of models inside their plastic bubble packs, but reflections remain a problem. Expect a large number of ruined shots.

Composing Your Shots

The first thing to decide is whether you want the subject to completely fill the photo, or if you want a little more of the background to be visible. This will determine how close you need to get to your subject. It is not necessary to have the subject dead centre, but nor should it be hiding away in one corner of the photograph. Set up the scene, adding any scenery or props that you want. Have trees or bushes overhanging a wall or fence for a natural look. The height of the models can be adjusted by using books or blocks of wood under the set-up.

Check to see how everything looks on the camera screen. Be especially careful of the edges of the photo. It is easy to miss some small problem until after you have taken the photo: the sky is not big enough to fill the background; part of your home decor is visible; part of the model has been chopped off. What about reflections? Did you remember to dust the model – with a large soft paint brush, never a household duster? Make any adjustments that might be needed, by moving either the camera or the subject back and forth, or using the zoom lens to compose the shot. For really close-up shots select the Macro setting. This will enable you to photograph just about any subject, no matter how tiny.

To help you compose your shots a grid, or overlay, can be displayed on the LCD screen. This will not appear on the photograph. I just find it annoying, so never use it. Shadows can be a problem, especially if they fall on the sky. Change the positioning and angle of the models, backgrounds, or the camera to reduce or eliminate them. Make sure you are not casting any shadows yourself. Sometimes shadows can be hidden by putting something in front of the backscene, to 'catch' the shadow before it falls on the sky or a distant mountain. Foliage is always a useful camouflage item for this sort of thing. Sometimes a backscene will catch the light, and appear washed out. Turn things around so the light does not fall directly on the backscene, or tilt it slightly forward, supporting it with something heavy just out of shot. The backscene will then appear darker, and more detail will be visible.

Clean and simple, with the Matchbox Stretcha Fetcha ambulance posed on a painted roadway, against a plain blue sky.

A badly composed shot, with the model up in one corner. There is far too much hillside in the foreground.

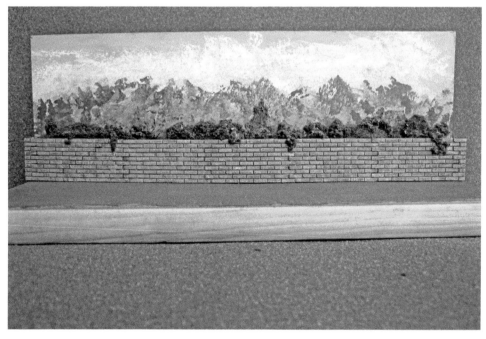

A length of 1:35-scale Tamiya Brick Wall, made up of several sections, painted as grey stone. The wall is spaced out slightly from the sponge-painted background, and small pieces of foliage and sponge are tucked into the gap. Paint the edges of the board to match the roadway.

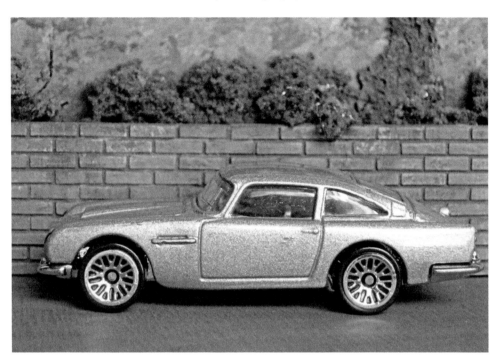

Hot Wheels Aston Martin DB5 parked in front of a stone wall, with a garden beyond – total depth of only a few millimetres.

Matchbox Jaguar SS 100 on a wooden board painted with grey texture paint. The foreground of the Peco backscene has been eliminated by raising the road surface up on another block of wood.

Corgi Charlie's Angels van, from the US TV series. The groundwork is egg carton papier-mâché, painted, and covered in model railway turf; otherwise known as grass. Paint the edge of the board to match the grass, or add more grass to the front for camouflage.

Extreme close-up of the Lamborghini insignia on the nose of a large Matchbox model. On the Macro setting it is possible to get in really close for shots like this, but the depth of field is very limited. The badge is 7 mm high.

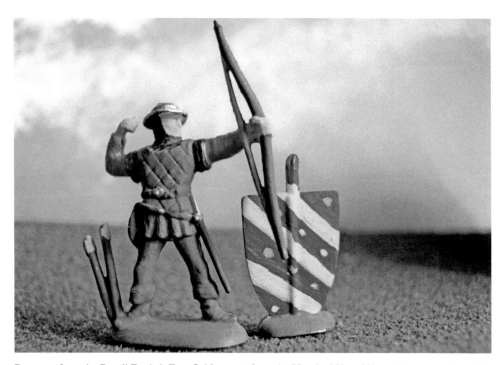

Bowman from the Revell English Foot Soldiers set, from the Hundred Years War, with a protective shield. Grass mat and painted sky.

Revell French Knight from the Hundred Years War. Adding some grass scatter to the base would make it less conspicuous against the grass mat.

Here the camera has focused on the backscene, rather than the model, which is rather blurred. Focus on the model, and take another shot.

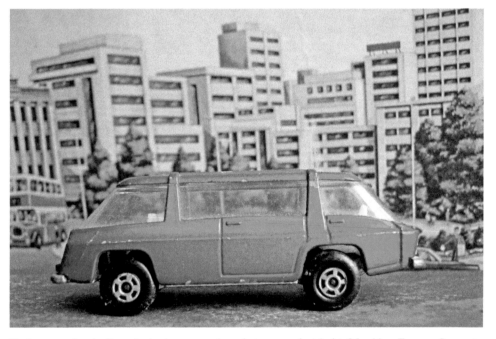

Dark grey card and a Peco city backscene are the only items used with this Matchbox Freeman Inter-city Commuter – but make sure your buildings are vertical.

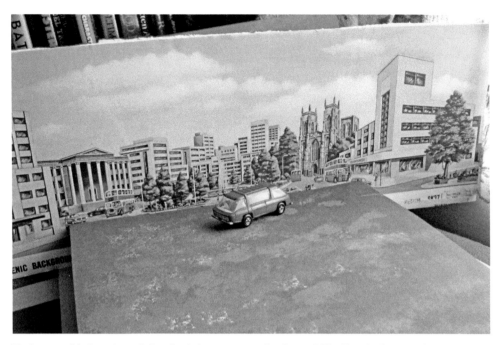

Dark grey or black card mottled with a lighter grey provides the road. The Peco backscene is large enough to provide several different backdrops, depending on how it is positioned.

Often a shot you think is in focus, turns out not to be as sharp as you thought. Due to the limited depth of field we have to work with, it is often easier to photograph a model from the side than end on, or at an angle. Lightly pressing the shutter button will focus the camera, and pressing it fully takes the photo. Sometimes the camera will automatically focus on the wrong part of a scene, leaving the main subject slightly blurred. Point the camera directly at whatever part of the scene you want to be sharpest, lightly press the shutter to focus, move the camera back to where you want it so that the whole subject in the shot – while still keeping the shutter lightly pressed to hold the correct focus – and finally press the shutter fully to take the photograph. Sometimes there may be more than one main subject, meaning that you need to get two or more parts of the scene in focus at the same time. In this case you just have to keep adjusting the scene, the camera, and the angles until everything is just how you want it. Photographing a two-headed dragon, and getting both heads in focus, was not easy; it took several attempts to finally get the shots I wanted.

A problem with diecast vehicles, which you seldom encounter with other types of model, is that by having wheels they may not stay where you put them. The runaway model is not only annoying, it could fall off the table and be damaged – this has certainly happened to me. Use small pieces of card to lift the far wheels off the table, or a discreet blob of Blu-Tack under the model.

A walk-around is a series of photographs of the same subject, usually including both general and close-up views, as you literally walk around the plane, tank, or car. Start at one point, and work systematically around the model, so you do not miss anything. Having the model on a board, or something similar, means that you can turn the subject in front of the camera, rather than moving around the model. A rotating cake/sandwich stand, or 'Lazy Susan', is ideal.

Many of the objects in the world around us are bigger than we are, so we spend a lot of time looking up – at buildings, elephants, and double-decker buses. Models are smaller than we are, and we usually look down on them. If they are photographed this way, they will look like models. A key way of making a model look real is to photograph it as we would photograph the real thing. This often means a low camera angle, looking up at the subject. Even when the subject is fairly low, such as an Italian supercar, keep the camera angle low. In this case 'eye level' means the eye level of someone sitting in the car, rather than standing next to it. I also like to have something in each shot that is taller than the model itself – a building, tree, or hill – as this looks more natural.

This magnificent two-headed dragon was picked up at a school fundraising fair, along with several other useful items.

Trying to get both heads of a two-headed dragon in focus at the same time is not easy – fortunately this fellow did not mind posing for the camera.

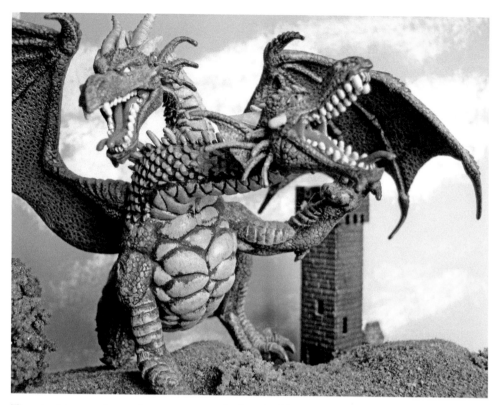

The ruined tower makes another appearance on the far side of the hill. Try to avoid shadows falling on the sky.

Toy elephant on a grass mat, with plain blue sky, and sponge-painted trees. Several shades of green are used, with the foliage being denser lower down.

Same grass mat, but now with a low hill, model trees, and a cloudy sky. Perhaps the setting does not look much like Africa, but it will do until we can make something more suitable.

Animals as well as people lend themselves to portraits. The eye and skin texture show up well, but the limited depth of field means the ear is slightly out of focus.

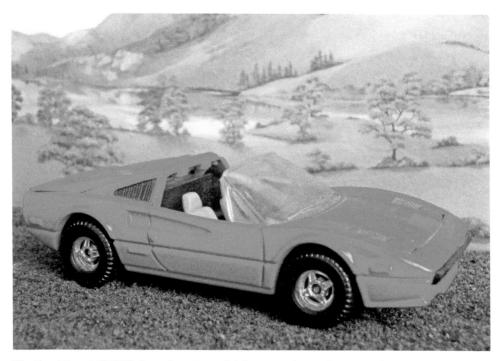

The Corgi Ferrari 308GTS. Apart from the model there are only two elements in this photograph. A length of wood covered in papier-mâché and Woodland Scenics grass, and a Peco model railway backscene depicting a mountain lake.

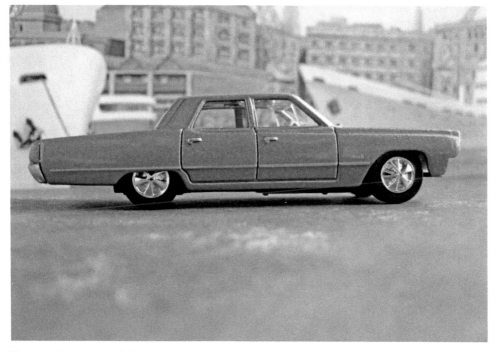

Keeping the camera angle low emphasises the size of this big American sedan by Johnny Lightning – even though it is only 82 mm long.

Matchbox Superkings Lamborghini Diablo. The road surface and hedge are both covered in tea leaves; the only difference is in the painting. Peco backscene.

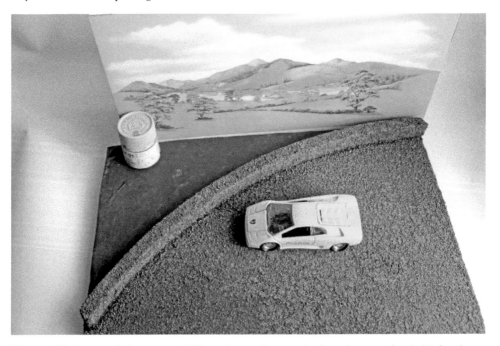

The curved hedge is made from a pair of old wooden coat hangers glued together, coated with dried tea leaves painted green, and dry-brushed with a lighter green to pick out the 'leaves'. The Peco backscene is being held upright by a paint jar.

Black

Black is a difficult colour to photograph. Black models often appear as just a dark shape, with little detail. Gloss black is even worse than matt black, due to reflections. If a dark object is photographed against a light background (or a light object against a dark background) this can throw off the automatic light metering. Focus as closely as possible on the subject, so that little of the background is visible. Use white card reflectors or a mirror to bounce more light on to the subject. You may also have to play around with the camera controls. If the brightness can be adjusted on your camera, it can be set to deliberately overexpose the subject to bring out the detail, while light objects can be underexposed. This will, of course, affect the backgrounds as well. To get rid of unwanted reflections, use a sheet of plain black card to one side, just as you would a normal reflector. Actually, the model will still be reflecting the objects around it, but this time it will be reflecting a sheet of plain card, disguising the fact there are any reflections at all. Chrome is also difficult to photograph due to reflections – 1950s American cars are certainly a challenge. Having just said all this, a light model against a light background, or a dark model against a dark background can also seem to disappear – some contrast is needed. It may be necessary to try several backgrounds to find one that suits the model. With experience, picking the right background first time will become easier, and there will be less trial and error.

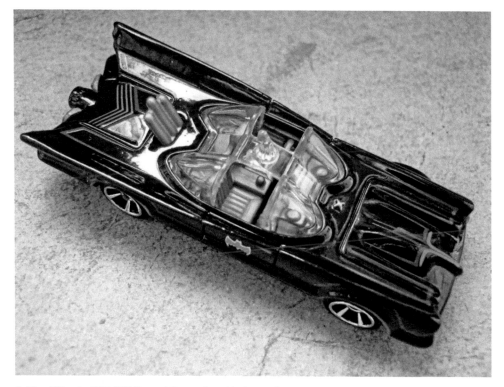

A Hot Wheels 1966 TV Batmobile in gloss black – reflections are a major problem with this colour. The ground is a piece of grey cardboard packaging, wiped over with an almost-dry brush.

Gloss-black Hot Wheels A-Team van. A piece of black card, just out of shot, will reduce annoying reflections.

A light-coloured model can become lost against a light background. The wall is painted plastic card while the steps are another toy skateboarding item.

Light-coloured models can stand out better against darker backgrounds, such as this hillside. Dark models may look better against a light background, as long as the contrast is not too great.

Vintage Style Photographs

Black and White or Sepia Photography

Digital cameras normally take colour photographs, but can be reset to take black-and-white, or even sepia-tinted photos. This will give the chosen photos a vintage look, making them appear contempory with certain subjects. Here, I am afraid, you will have to read your camera manual for instructions on how to do this. Alternatively, colour photos can be converted to black and white or sepia by various computer photo-editing programmes. If you do this, it is best to keep the colour original, and save a black-and-white or sepia copy.

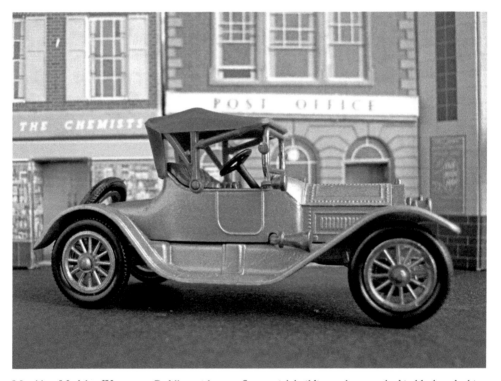

Matchbox Models of Yesteryear Cadillac, with some Superquick buildings, photographed in black and white. If the buildings are not glued together they can be rearranged. The model is posed in front of the chemist and the Post Office rather than the cinema, as the film playing at the Savoy is *The Music Man* from 1962 – which would look very odd with a 1913 car.

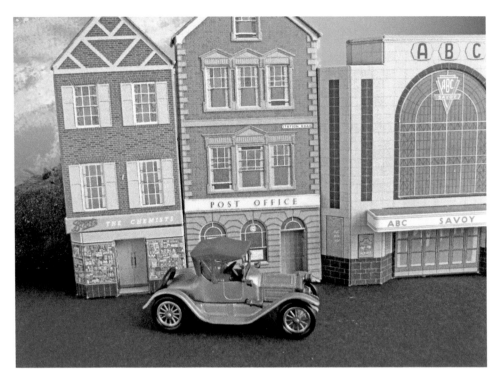

This Models of Yesteryear car is considerably larger than the OO (1:76 scale) buildings behind it, but this is not obvious if the models are carefully posed.

Setting the camera on 'sepia' gives a period look to photographs, appropriate for this nineteenth-century Gatling gun.

British Timpo plastic 54-mm soldiers with a Gatling gun. Grass mat, hill, and painted sky.

Sepia Scenes

There are several ways you can make the main subject of a photograph stand out from its surroundings. What I call 'sepia scenes' put a full-colour model in front of a monotone background, which can be sepia, like a vintage photograph, or any other colour you wish. Illustrations like this are sometimes seen in books or advertising. I originally thought this technique would be mainly suitable for models of vintage vehicles, but it actually works well with any type of model.

The ground surface, background, and sky all need to be variations of the same basic colour, such as brown or green. Any props – trees, fences, or buildings; even people and animals – need to be painted various shades of the same colour. Model trees and bushes usually come in various greens, but 'dead' foliage is also available in brown, and there are autumn shades of yellow, orange, red, and red-brown, although the trunk may need painting to match the foliage.

It will probably be necessary to draw or paint your own single-colour backscene, but a few blobs and streaks will do, suggesting distant trees or hills. Brushes, pieces of sponge, or felt-tip pens are all suitable. Trees or loose foliage can be used to help hide the backscene, so it is only half visible.

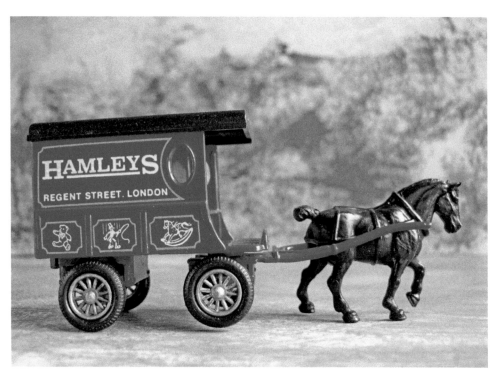

A sepia scene, with a full colour Lledo horse-drawn delivery van against a painted monotone background. The road and backscene are simply random streaks and blobs of brown paint on two pieces of grey card.

Matchbox Greyhound bus outside a sepia scene café. This was drawn with a felt-tip marker pen – the sort with both broad and narrow ends – and a ruler.

Lledo Vanguards Morris Minor Traveller. A sepia scene with foliage: brown painted backscene, and autumn-coloured clump foliage.

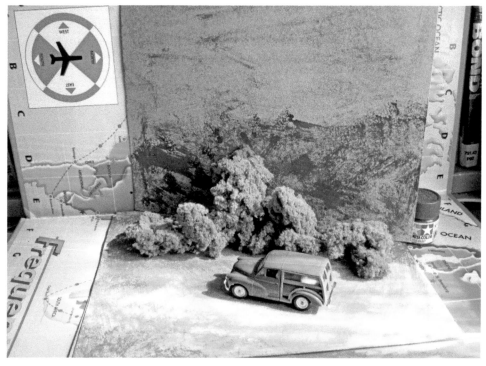

The complete Traveller set-up. The game side of the old gameboard that provides a plain blue background in several other shots, with loose clump foliage simply piled up behind the model.